NEWCASTLE
THEN & NOW

IN COLOUR

ROB KIRKUP

The
History
Press

First published in 2013, reprinted 2015

The History Press
The Mill, Brimscombe Port
Stroud, Gloucestershire, GL5 2QG
www.thehistorypress.co.uk

British Library Cataloguing in Publication Data.
A catalogue record for this book is available from the British Library.

ISBN 978 0 7524 6566 1

Typesetting and origination by The History Press
Printed in China.

CONTENTS

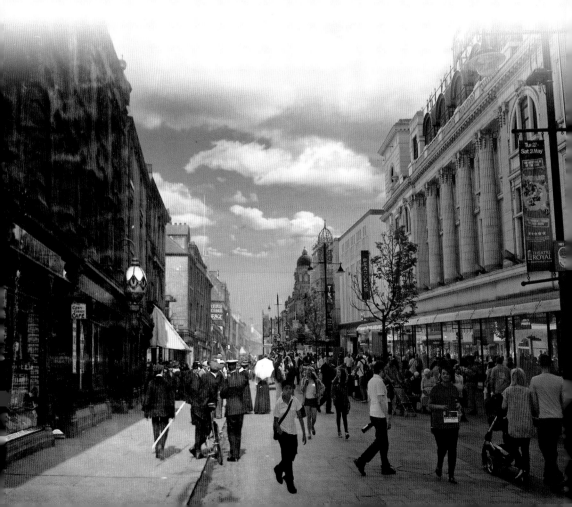

ACKNOWLEDGEMENTS

Many thanks go to my family, especially my wife Jo, my mum and dad, and my brother Thomas.

Also thanks to my friends for their support during the compiling of this book. A special mention to Andrew Markwell and John Crozier, who accompanied me on many trips across the city taking the photographs you will see throughout this book.

The archive images were provided by Newcastle City Library.

ABOUT THE AUTHOR

Rob kirkup is a keen local and paranormal historian. He is the author of a number of regional books and has his own website: www.ghostsofthenortheast.co.uk. He lives in Wallsend, Tyne & Wear.

INTRODUCTION

The recorded history of Newcastle-upon-Tyne dates back almost 2,000 years to AD 120, when the country was under the control of the Romans. It was the Romans who built the first bridge to cross the River Tyne. This bridge was called *Pons Aelius* or 'Bridge of Aelius' – Aelius being the family name of Emperor Hadrian. Thirty years later, a stone-walled fort was built to protect the river crossing. This settlement took the name of the bridge and became known as 'Pons Aelius'.

After the Romans left Britain, it fell under the rule of the Saxons and then the Danes. The name 'Newcastle' dates back to the Norman conquest of England, in particular 1080, when King William sent his eldest son, Robert Curthose, to a settlement then named 'Monkchester' to construct the building of a 'New Castle'.

Due to its advantageous position on the River Tyne, the town continued to develop greatly during the Middle Ages, becoming an important centre for the wool trade and, later, one of the major coal mining areas in the world.

In 1636 the Black Death hit Newcastle, with over a third of the 20,000 people living in the town losing their life to the plague.

Newcastle was granted city status in 1882, and has never looked back. Today, it is a major commercial and cultural centre with the sixteenth highest population of any city in the United Kingdom.

Twenty-first-century Newcastle is known the world over for its vibrant nightlife, Newcastle Brown Ale, the iconic Tyne Bridge, Premier League football team Newcastle United, and the Great North Run – the world's most popular half marathon.

Almost 20 million visitors from across the world come to Newcastle each year, helping the local economy to the tune of over £1 billion, and with such exciting diverse areas of the city on offer, it is easy to see why so many people come here each year, and why the Geordie populous are so proud of Newcastle. The Geordies themselves are famous for their warm, friendly spirit, their often difficult to understand but much-loved dialect and accent, and, of course, never wearing a coat for a big night out in the Bigg Market or down the Quayside, even in the harshest of weather. The Quayside is a spectacular riverscape, day and night, with seven bridges linking the city to neighbouring Gateshead.

Fantastic shopping is to be had on Northumberland Street and inside Eldon Square – one of the UK's largest city centre shopping complexes, covering 1.4 million square feet.

Newcastle's Castle Keep, the building that started it all, remains as one of the finest examples of a Northern Keep in the country, and Grainger Town's stunning neo-classical architecture is nowhere better visible than on the beautiful Grey Street, one of the finest streets anywhere in the country.

Rich heritage, world-class culture, fine dining, exceptional shopping and some of the country's most acclaimed architecture are all here, just waiting to be discovered.

Rob Kirkup, 2013

ALDERMAN FENWICK'S HOUSE

THIS HOUSE AT 98 Pilgrim Street is the oldest brick-built house in Newcastle city centre, and one of the most important mercantile townhouses in the North of England. The structure of the building is quite complex, built of two adjoining and linked buildings; the first being a merchant's house, which can be dated to before 1695, while the second can be dated to around 1779. There have also been extensions built that have, over the years, been demolished. The ceiling of the Great Room and the oak staircase, rising into the Lantern Tower, are in keeping with the period of the much earlier merchant's house. The building is named Alderman Fenwick's House because that is how it was attributed on a map from 1723,

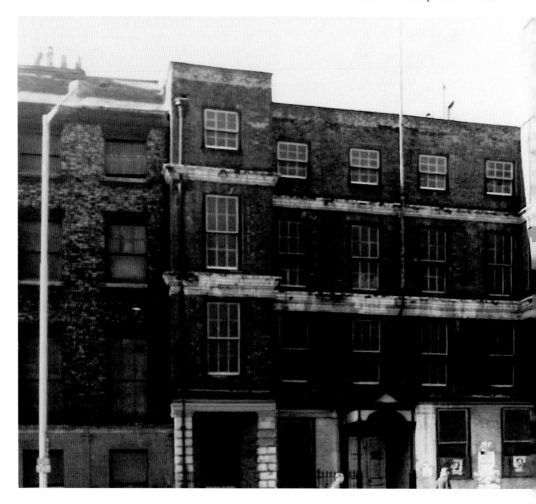

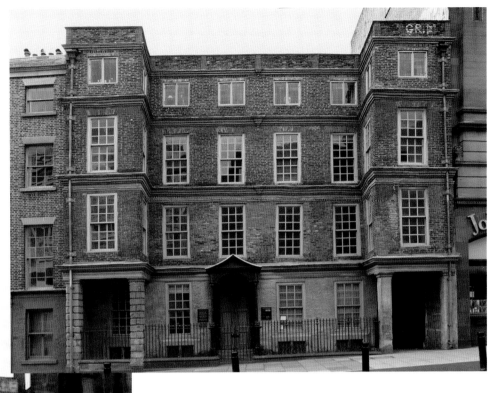

and the name has stuck. In the late eighteenth century it became part of the Queen's Head Hotel, and from 1880 until 1962 it was the Newcastle Liberal Club.

The photograph on the left, taken in 1976, shows the building in a derelict state, following the Newcastle Liberal Club's ownership, after which it stood empty. The owners at the time applied for consent to demolish but this was refused.

IN 1980, THE Tyne & Wear Building Preservation Trust appointed Simpson & Brown to carry out structural and internal repairs to the buildings. Following completion of the first phase in 1983, funding failed, and, with no money to carry out the much needed repairs, the building stood empty until 1996. The Heritage Lottery Fund agreed to support the project and the work was resumed and completed the following year. The Trust own the Grade I listed building to this day and use part of it for office space. The rest of the building is let to businesses on a commercial basis. Alderman Fenwick's House is not open to the public, but regularly takes part in the city's annual Heritage Open Days Weekend, allowing visitors a glimpse inside one of Newcastle's most impressive houses.

ALL SAINTS' CHURCH

A CHURCH IS recorded on the site of the present All Saints' Church (pictured on the right around 1900) since 1286. The previous medieval building, the Church of All Hallows, stood in a picturesque location overlooking the River Tyne, but by 1875 it was in such poor condition that estimates were sought from local architects for restoration. Two such architects, David Stephenson and John Dodds, reported that the building had decayed to the point where it would cost more to repair it than it would to build a new church. In April 1786, a general meeting of the parishioners was held and they unanimously voted, with great sadness, for the church to be demolished and have it replaced with a new church. The church was demolished shortly afterwards, with none of the building being retained; everything was either destroyed or disposed of. The tower had to be blasted with gunpowder as the mortar was bound so strongly. In doing so, well-known parishioner Captain William Hedley tragically lost his life when a large stone from the western face fell on him as he stood below, watching the work.

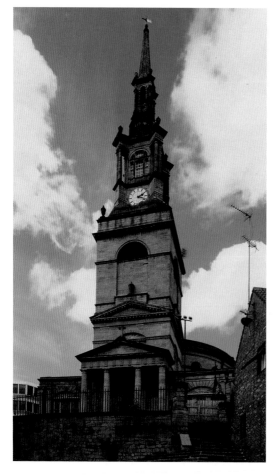

DAVID STEPHENSON'S ARCHITECTURAL design was accepted, and the foundation stone was laid on 14 August 1786 by the vicar of Newcastle, Revd James Stephen Lushington. Construction took ten years, and the final building costs were £27,000. The church has a rounded, elliptical body, which is entered through a detached portico with four columns in the form of the Pantheon at Rome. The complex roof, without any supporting pillars, is an astounding piece of carpentry. On 17 November 1789, the new All Saints' Church was consecrated by Revd Thomas Thurlow, Lord Bishop of Durham, and the opening sermon was preached by Revd Hugh Moises. Undoubtedly one of the city's most beautiful buildings, All Saints' Church still remains today, and is a rare example of an elliptical church. Despite being badly flooded in the winter of 2009 and again in 2010, and being deconsecrated in 1961, the church remains open to the public (although less often following the flooding) and is by no means derelict.

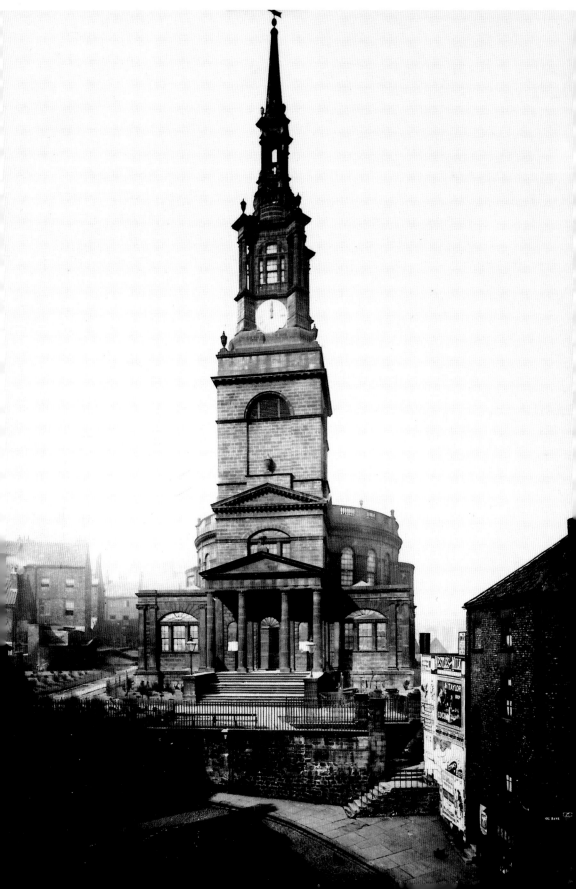

THE ASSEMBLY ROOMS

BUILDING BEGAN ON the Newcastle Assembly Rooms on 16 March 1764 and cost £6,700; funding came from 129 shareholders – holding 234 shares at a cost of £25 each – and the Newcastle Corporation contributing a further £200. The foundation stone was laid by the late William Lowes Esq. and a plate with the following inscription was placed beneath the stone:

In an age
When the polite arts
By general encouragement
and emulation,
Have advanced to a
state of perfection
Unknown in any former period;
The first stone of this edifice,
Dedicated to the most
elegant recreation,
Was laid by William Lowes Esq.
On the 16 of May, 1774.

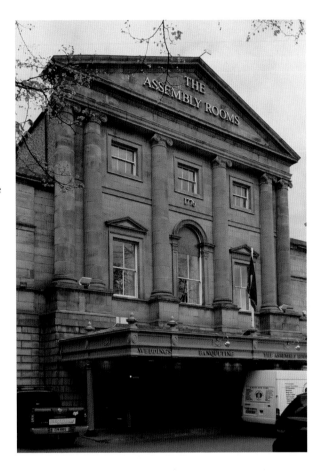

The Assembly Rooms were designed by William Newton, the most successful architect in Newcastle in his day. They were built in a Georgian design, and seven Rococo chandeliers were fitted, which were built locally in Newcastle and comprised of 10,000 pieces of hand-cut crystal. It was opened on 24 June 1776 as a meeting place for the city's high society. Charles Dickens performed three playlets here on 27 August 1852, and Straus gave a concert on 21 October 1838. The Assembly Rooms has received many royal visitors over the years, including Edward VII, George V, and George VI.

IN 1967, THE Assembly Rooms fell into disrepair, and with no buyers wishing to take on the rundown and vandalised building, it looked likely that the building would be demolished. On 24 June 1974, however, Michael and Homer Michaelides bought the building and spent £250,000 restoring it to its former glory, and it has remained in the family ever since. Due to rebranding, the name changed from the Old Assembly Rooms to the Assembly Rooms twelve years ago. Today, this lovingly restored Georgian building is run as one of the city's premier conference, banqueting and wedding venues.

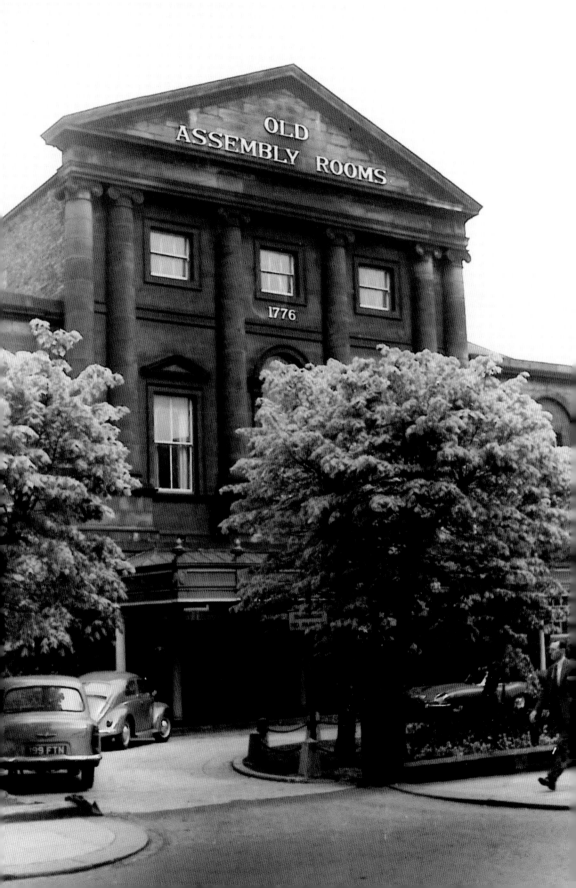

BESSIE SURTEES HOUSE

SITUATED ON SANDHILL, a street on Newcastle's riverfront, these two, five-storey sixteenth- and seventeenth-century merchants' houses (pictured below in 1950) are collectively named Bessie Surtees House. The two buildings, originally numbers 41 and 44 Sandhill, were known

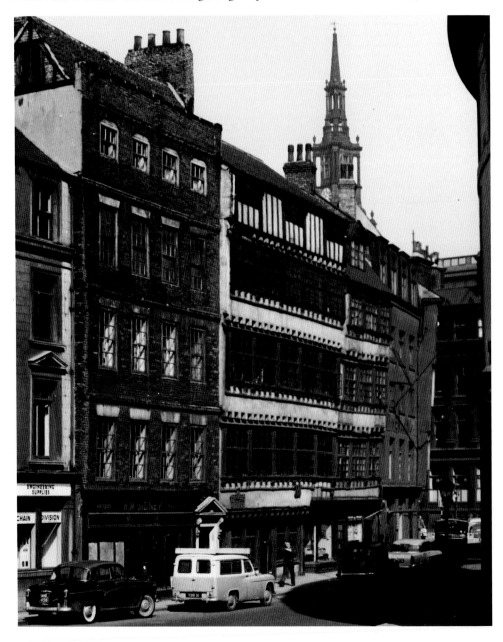

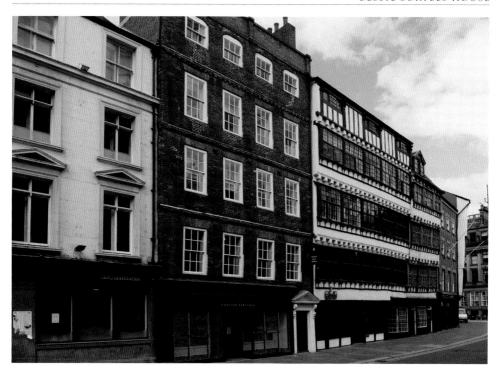

respectively as Milbank House in the sixteenth century and Surtees House in the seventeenth
century. The two houses became one in the 1890s when John Clayton, who already owned
Milbank House, bought Surtees House and joined them together. He added a new shop front
to Milbank House in around 1900. The house is best known as the scene of the elopement of
Bessie Surtees, the 17-year-old daughter of wealthy merchant and Mayor of Newcastle, Aubone
Surtees, who lived on the Quayside at the end of the eighteenth century. Bessie fell in love with
a 22-year-old Scotsman, John Scott, who was beneath the Surtees on the social ladder, and, as a
result, her father forbade her from ever seeing him again. However, on the night of 18 November
1772, Bessie climbed out of her window and down a ladder into John's arms. They hurried to
Blackshiels, a village near Dalkieth, where they were married. Shortly afterwards, they returned
to Newcastle and were welcomed by John's mother and father, who invited them to live in their
house on Love Lane. Aubone was not so forgiving and refused to see Bessie. He quickly realised
the love he had for his daughter was far more important than his bruised pride, and so, with
the blessing of her father, Bessie and John had an English wedding at St Nicholas Church on
19 January 1773. John Scott would go on to become Lord Chancellor of Great Britain in 1801.

AS IT STANDS today, the house provides a rare example of well-preserved domestic architecture from
the Jacobean period. It stands five storeys high, with each floor slightly overhanging the one below,
and the windows extend across the full width of the house. The interior is decorated in grand oak
panelling and elaborate plaster ceilings. Bessie Surtees House has been in the ownership of English
Heritage since 1989, and the rooms on the first floor are open to visitors, free of charge, and contain
an exhibition illustrating the history of the houses. The rest of the building is in use as offices.

BLACKFRIARS

DURING THE THIRTEENTH century, Orders of friars established themselves across England. The Dominican Order was founded by St Dominic, also known as Dominic of Osma, and established in 1221. The Dominicans wore white tunics and black cloaks – which gave them the name Blackfriars – unlike the Franciscans (established in 1274) who wore grey cloaks and were, therefore, known as the Greyfriars. Dominicans were forbidden from owning land, but it could be held in trust for them. This was the case with Blackfriars friary (pictured below in 1904), which was founded by Sir Peter Scot, the first Mayor of Newcastle, and was built in the thirteenth and early fourteenth centuries. The 7-acre friary was constructed just inside the city walls in the north-west of Newcastle. In 1536, Henry VIII's Dissolution of the Monasteries saw

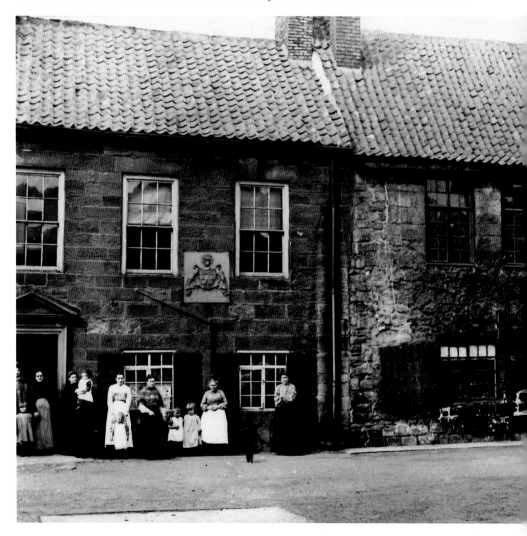

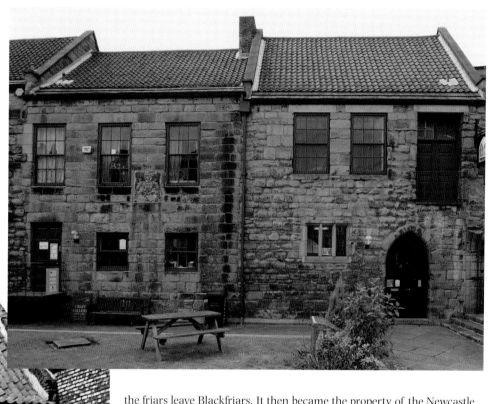

the friars leave Blackfriars. It then became the property of the Newcastle Corporation, who, in 1552, granted it to the most 'ancient trades and mysteries of the town' to be used as their headquarters. During the late sixteenth and early seventeenth centuries, the city's nine craft guilds – Cordwainers, Smiths, Fullers & Dyers, Tanners, Brewers & Bakers, Saddlers, Butchers, Tailors, and Skinners & Glovers – carried out extensive changes to convert the cloistered buildings, to make them suitable for their own use. The guilds' meeting houses within Blackfriars remained in use until the nineteenth century. The guilds met fairly infrequently, so, in the periods of inactivity, ground-floor rooms were used as free dwellings for the homeless and needy, and for people in the employ of the guilds.

AFTER THE GUILDS had ceased to use Blackfriars, the buildings quickly fell into a state of disrepair. Newcastle Corporation re-acquired Blackfriars in the early 1950s, and in the late 1970s a restoration programme commenced and some meeting rooms were created. Today, craft workshops and shops occupy the building. The Café Bar is located in the twelfth-century refectory and offers food and drink in what is the oldest restaurant building in England. Blackfriars also houses an exhibition describing the friary's history. The large grassed courtyard offers a serene contrast to the busy city which has grown around it, with the city's Chinatown nearby.

THE BLACK GATE

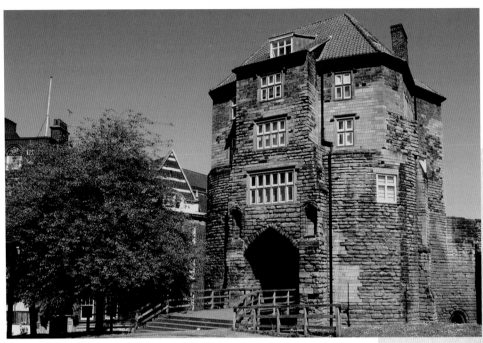

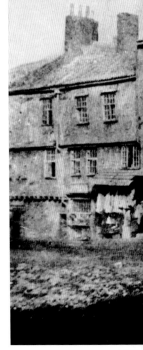

THE BLACK GATE was added to Newcastle Castle between 1247 and 1250, during the reign of King Henry III. It was the gatehouse of the barbican – a walled, defensive entrance passage for the castle's North Gate. It was sealed by a portcullis mounted in vertical grooves in the walls – which are still visible today. It could be raised or lowered quickly by chains attached to a winch. The angle to the rest of the castle and the narrowness of the passageway left attackers vulnerable to fire from the forces of the castle. At the front of the gate was a drawbridge with a bridge at the rear. Both have since been replaced with wooden footbridges. The present upper floors, roof and false arch over the gateway were seventeenth-century additions, when the unused gatehouse was leased in 1619 and rebuilt as a house by Alexander Stephenson. It was later in the ownership of London merchant Patrick Black, who, in 1649, first used the name Black Gate. By the early nineteenth century, the immediate neighbourhood around the Black Gate had become one of the poorest areas of the town, and the building itself was a slum tenement, with up to sixty people living in houses built along both sides of the defended passageway. One part of the building had even become a public house ran by John Pickells, whose name, along with the date 1636, appear on a stone high up on the south-west wall.

In 1856 there were plans to demolish the Black Gate, on the grounds that it was considered 'a great nuisance' by the town authorities. The picture below (taken in 1860) shows buildings built tightly together and covering almost half of the frontage.

EVENTUALLY, THE NEWCASTLE Corporation bought the castle and the buildings within its walls, which included the Black Gate. In 1883, the Black Gate was leased to the Society of Antiquaries, and over the next two years they restored the gatehouse and converted it into a museum. It served as a museum until 1959, and the Society continued to occupy it until 2009, using the gatehouse as a meeting place and library. In autumn 2011, it was awarded a £1.4 million grant by the Heritage Lottery Fund, which will be spent restoring the Black Gate so that it can be opened to the public for educational, heritage and community projects.

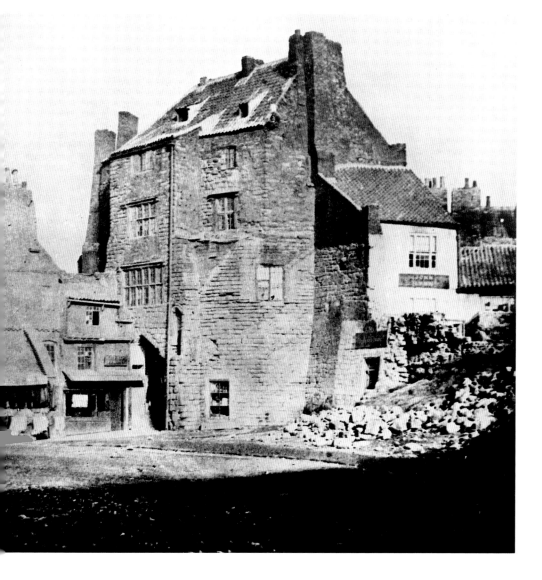

CARLIOL HOUSE

CONSTRUCTION OF THE new Tyne Bridge, between 1925 and 1928, would see the character and purpose of Pilgrim Street transformed. With a far greater increase in the river crossing capacity between Gateshead and Newcastle, Pilgrim Street would become the main arterial route through the city. As a result, a decision was made to make Pilgrim Street appear much grander than the previous medieval development had been. Carliol House was opened in 1927 as the headquarters of NESco (Newcastle Electric Supply Company). It was built of Portland Stone, and faced the new police station, magistrates' court, and police station that were built

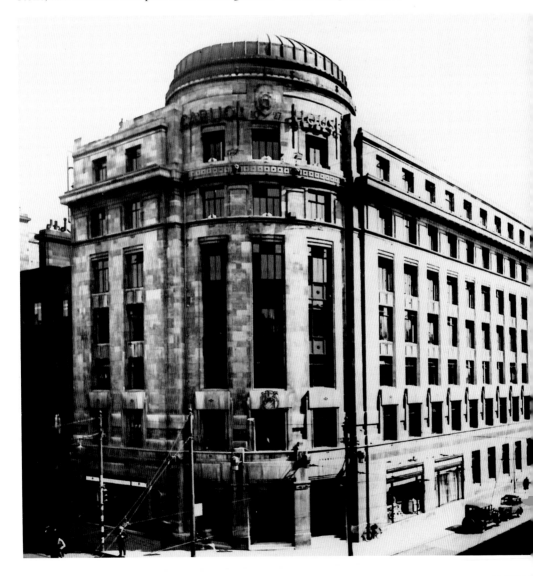

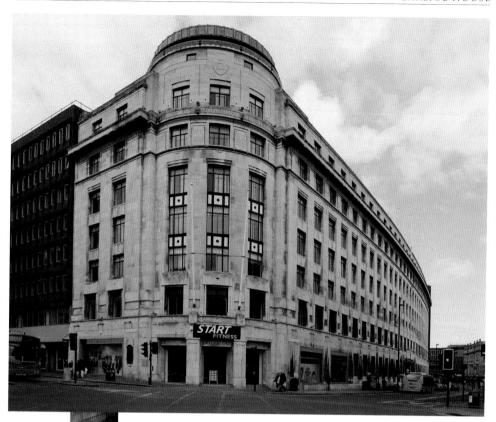

from the same stone. All four buildings were designed by Robert Burns Dick, the Scottish architect who had moved to Newcastle as a child. He was responsible for many of the city's significant buildings, including the Vermont Hotel, which was originally built as Northumberland County Council's offices – his were the towers either side of the Tyne Bridge.

This image of Carliol House (left) was taken in the late 1940s and shows the 'Carliol House' lettering around the top of the building; the NESco logo can be seen one window up from the entrance to the building. Period automobiles can be seen parked outside, and tramwires and tramlines belonging to the Newcastle Corporation Tramways, which ran until 1950, can also be seen. In 2000, Northern Electric and Gas Ltd put Carliol House up for sale, due to it being considered too big and expensive for their present-day needs.

TODAY, THE GRADE II listed building remains largely unchanged; the lettering around the top of the building is no more, and a hole in the brickwork remains where the NESco logo was previously. It is currently home to Start Fitness, a local sports equipment chain.

THE CASTLE KEEP

THE FORMIDABLE CASTLE Keep is Newcastle's original landmark; the oldest building in the city and the fortress from which the name 'New Castle' came. In 1080, Robert Curthose, eldest son of William the Conqueror, founded a motte-and-bailey castle on the site of a former cemetery in a settlement known as Monkchester – a strong, defensive position above the River Tyne, protected to the north and the east by the Lort Burn. By the early twelfth century a town had grown around the site of the castle, which took the name *Novum Castellum*, meaning 'New Castle'. Between 1168 and 1178, King Henry I ordered that the castle be rebuilt in stone at a cost of £1,144 5s 6d. A rectangular stone keep was built, and a triangular stone bailey replaced the existing wooden one. During the construction, William 'the Lion' of Scotland led an invasion, but was captured and held in the castle. Evidence of this invasion is present to this very day, with a fifteen-step staircase coming to an abrupt stop against a wall on the second floor of the castle's keep. In 1400, Newcastle became a town and a county, although the castle and its land remained part of Northumberland. The strategic importance of the castle declined and it became Northumberland's county gaol. The upkeep of the castle was neglected for over 200 years and it fell into disrepair, with some walls and the roof beginning to decay and crumble. In 1638, with the political situation with the Scottish decidedly fragile, Newcastle braced itself for war and partially rebuilt the castle. In 1810, the Newcastle Corporation bought the castle (which was now a ruin) for 600 guineas, and by 1813 the Castle Keep had been restored and opened to the public. It was in the 1840s that the fragile remains of the once powerful castle faced its greatest enemy: the arrival of the railway. Between

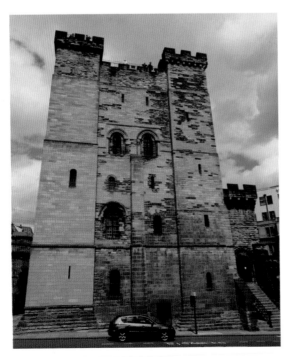

1847 and 1849 a railway line was built right through the centre of the castle, splitting the remains in two. It looked likely that the remaining buildings of the keep and the Black Gate would be demolished, until the Society of Antiquaries acquired the remains, cleared the surrounding land, and employed the services of celebrated architect John Dobson to carry out further restorations.

TODAY, THE CASTLE Keep is open to the public seven days a week, giving visitors the chance to step back in time to when this castle stood strong against invading armies from both home and abroad. Although now standing in isolation, it's difficult not to be impressed by the intimidating keep.

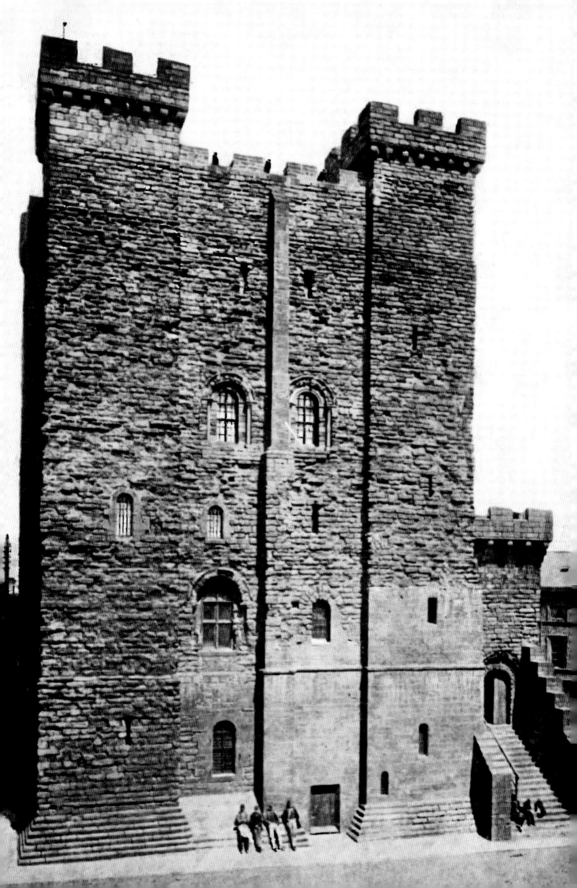

THE CENTRAL ARCADE

THE CENTRAL ARCADE (pictured on the right in 1966) was originally built in 1838 by Richard Grainger. This elegant design was intended for use as a corn market but it was turned down by the town's authorities because a corn market was already planned opposite St Nicholas' Church in Mosley Street. Instead, the large interior became a spacious, elegant subscription newspaper reading room, which opened in 1839.

In 1867, the arcade was ravaged by fire and was rebuilt as an art gallery and concert hall. However, the building generated little interest and, due to lack of visitors, it closed down in 1869. In 1870, the building re-opened as an art gallery and news room. Proving to be a great success, the venture expanded and by 1892 the Central Exchange News Room, as it was now named, contained an art gallery and a magnificent concert hall capable of seating over 1,000 people. The Central Exchange Hotel was also opened, overlooking Grey Street and Market Street. The hotel contained a billiard room, smoking rooms, sitting rooms, and fifty bedrooms.

IN 1900, HOWEVER, disaster struck as the building was once again consumed by fire and destroyed. In its place, the Central Arcade opened in 1906 as an impressive shopping centre, featuring a glass barrel-vaulted roof and glorious mosaic tile work. Visitors to the Central Arcade today will discover that the magnificent building's decoration remains as it appeared when it first opened over 100 years ago. Many locals refer to the Central Arcade as 'Windows Arcade', on account of the music shop, JG Windows, that takes up much of the shop space within the Arcade. JG Windows is one of the oldest music shops in the UK, celebrating its 100 year anniversary in 2008. The building is bounded on three sides by Grainger Street, Grey Street and Market Street, with entrances serving all three streets.

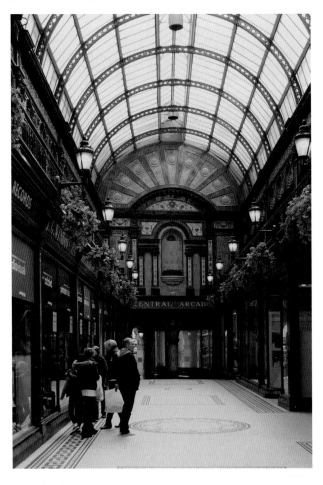

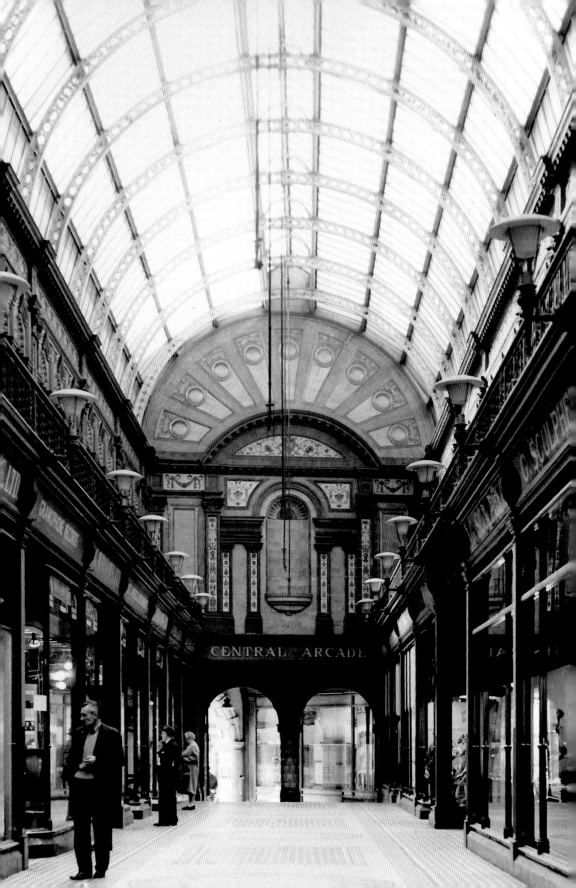

THE CHURCH OF
ST JOHN THE BAPTIST

STANDING ON THE corner of Westgate Road and Grainger Street, the church of St John the Baptist (pictured below around 1910) is one of Newcastle's oldest buildings dating back to around 1287, and still stands strong almost 750 years later. The fifteenth-century font cover and the Jacobean pulpit are fine examples of local woodwork, and the choir stalls were hand-carved in the mid-1930s by Yorkshire carpenter Robert Thompson, who carved mice into everything he made, earning him

the nickname of the 'Mouseman'; the stalls at St John's are no exception, with four mice carved into them. The north wall contains a window, which includes fragments of medieval glass from about 1400, with the earliest known representation of the Newcastle-upon-Tyne's coat of arms. Further along the wall, an opening in the form of a cross can be found. This was part of the wall belonging to the cell of an anchorite – a man who had chosen to withdraw from the world for his religious beliefs. The opening allowed him to look out and watch the service. In 1829, celebrated Newcastle architect John Dobson restored the chancel – now the Lady Chapel – and the gables. Part of the graveyard was built over in the 1950s and '60s, for the construction of a hall and meeting rooms; most of the rest has been paved over. Sadly, there are currently less than ten gravestones remaining; the rest were either used to pave the new churchyard, or were relocated to St John's cemetery in Elswick.

STANDING IN A churchyard full of trees, the now Grade I listed Church of St John the Baptist is a true delight standing amongst many modern-day buildings much taller than the church itself. It is surrounded on all four sides by popular public houses: Yates' Wine Lodge, the Sports Café, JD Wetherspoons' Union Rooms, and the Long Bar.

THE CITY HALL

PICTURED BELOW IN 1930, the City Hall was opened as a general purpose hall in 1927 as part of the redevelopment on Northumberland Road, which also includes the adjacent City Pool. In 1928, an organ made by Harrison & Harrison of Durham was added; it is the 'Rolls-Royce' of organs, with over 4,000 pipes – this addition gave Newcastle its first concert venue, with tickets costing around two shillings (10p). Musically, the hall got off to a slow start, with many empty seats. This was largely due to ticket prices being considerably higher than that of the Palace Theatre in nearby Haymarket, where a seat in the 'Gods' to an opera

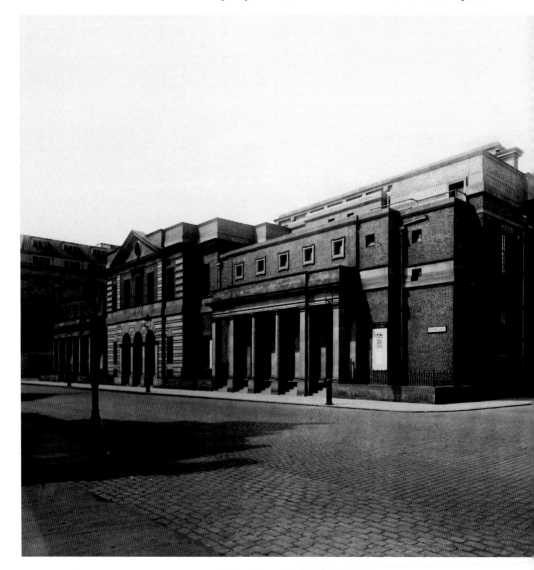

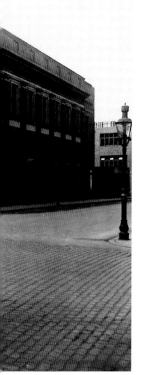

performance cost three pence (1.5p). In the decades that followed, the City Hall held celebrity recitals and civic functions.It also played host to concerts by major British orchestras, featuring conductors such as Sir Malcolm Sargent and Sir Thomas Beecham, as well as top international orchestras, including the Berlin Philharmonic and the Prague Philharmonic. Local choirs and societies held their annual concerts here. In the 1960s pop music exploded onto the scene, and the City Hall was quickly playing host to shows which had several of the top acts of the day on the same bill for just 10s 6d (52p) or less. The Rolling Stones, the Kinks, Gerry and the Pacemakers, and the Beatles all played at Newcastle City Hall, with the latter playing four times in total; three times in 1963, and then again in December 1965 – during their last ever UK tour.

THE CITY HALL continues to host all the top music acts, and remains as one of the best 2,000-seat venues in the country. As well as this, it also has a reputation for hosting sell-out comedy shows. Externally, the City Hall façade remains almost identical now to how it did when it opened over eighty-five years ago. The Harrison & Harrison organ, although in a poor state of repair and under-used for thirty years, was awarded a Grade I Historic Organ Certificate in 2003.

THE CORNER HOUSE HOTEL

THE CORNER HOUSE Hotel, pictured on the right shortly after opening, was built at the same time as the adjacent Lyric Cinema, and is conveniently situated at the corner of Heaton Road and Stephenson Road in Heaton, in the east end of Newcastle. The hotel was designed by Marshall and Tweedy for James Deuchar Ltd, and opened its doors to guests for the first time on 8 January 1936.

THE TRAMLINES THAT once ran past the Corner House have long gone, and the Coast Road (A1058) – a busy dual carriageway – runs past the front of the building. The Lyric Cinema still remains next door, but, in 1962, was bought and renamed the People's Theatre. No longer a hotel, it is rare to find an empty seat outside the front of the Corner House during the summer months, for it is today a

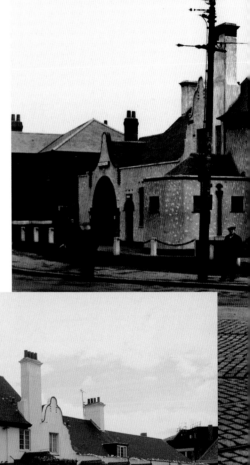

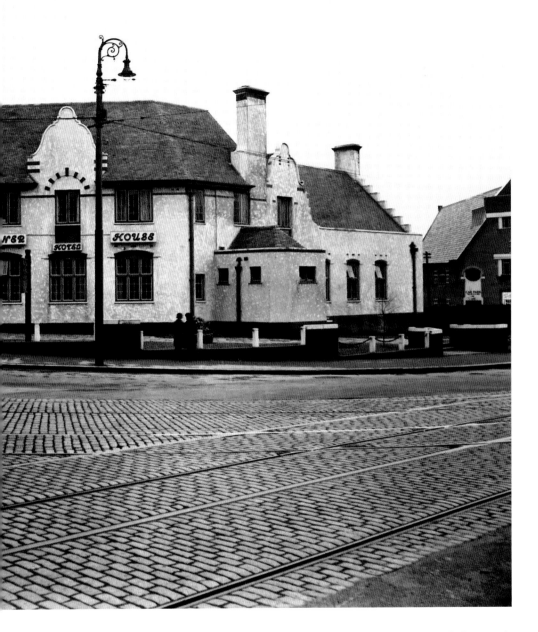

very popular pub, especially with the large student population of Heaton. It is usually busy with people looking to make the most of the discounted drinks, the good value pub meals, and the regular entertainment, in the form of pub quizzes, poker nights, and live bands.

EXHIBITION PARK

IN 1870, THE Town Moor Improvement Act saw two areas of land, both 35 acres in size, made available for development as recreational use. One became Leazes Park, which opened in 1873, and the other was a section of the Town Moor, named the Town Moor Recreation Ground. In 1887, the Royal Jubilee Exhibition was held here to celebrate the fiftieth anniversary of Queen Victoria's reign, attracting over two million visitors and unintentionally giving the park the nickname of Exhibition Park.

This image (below) was taken in 1910 and shows Edwardian residents of the city enjoying a performance on the bandstand, which was built specifically for the earlier Jubilee celebrations. This is the only remaining item in the park from the 1887 exhibition and is, sadly, rarely used.

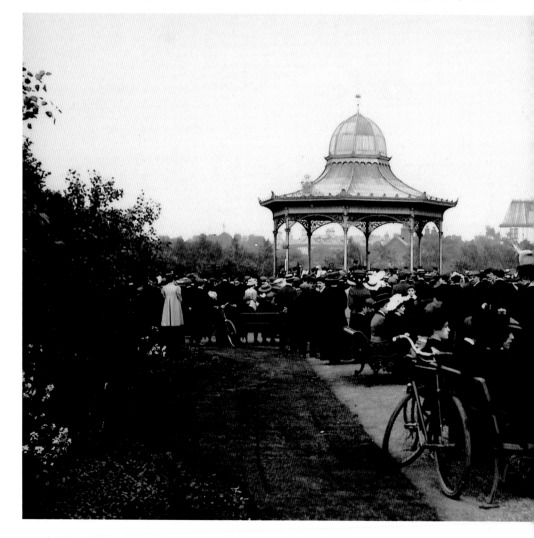

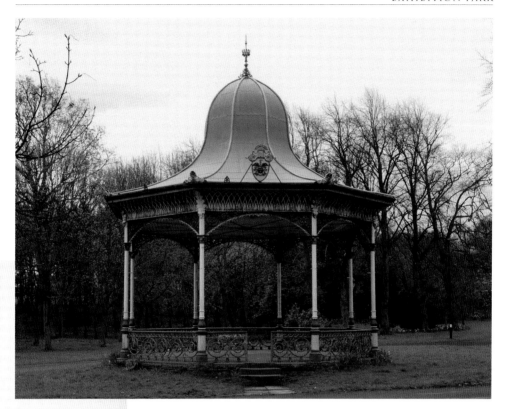

After being a commonly used nickname for over forty years, the park was officially renamed Exhibition Park in May 1929, when the North East Coast Exhibition was opened by HRH the Prince of Wales. Held during a period of great economic hardship, this exhibition was an attempt to boost local industry and commerce. Running from May until October, it was a roaring success – with over 4.3 million visitors attending during the sixth-month period – which ended with an enormous fireworks display. Today, the now disused Military Museum is the only building remaining from the exhibition. The Tyneside Summer Exhibition was held at the park from the 1960s by Newcastle Council, with the aim to generate the same feel-good factor throughout the city that previous exhibitions had brought. This was run annually until 1987, in which year the event generated a £60,000 loss.

TODAY, EXHIBITION PARK is still a popular venue for many outdoor events; from parents and toddlers at the swing park, to teenagers at the skate park (which opened recently at the main entrance to Exhibition Park) and the annual Al Mela – a celebration of Asian cuisine, music and art held over the August bank holiday weekend.

THE GRAINGER MARKET

PICTURED BELOW IN around 1920, the Grainger Market is a Newcastle institution. It was built as part of Richard Grainger's nineteenth-century redevelopment of the city centre, and was designed by John Dobson. The market place covered over 8,000 square metres, making it the largest indoor market in the world at the time. It was divided into two parts: the eastern section, a meat market laid and out in a series of aisles, and the western section, a vegetable

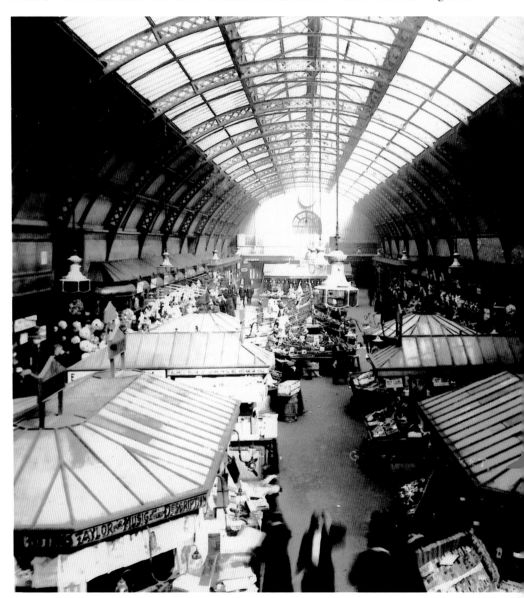

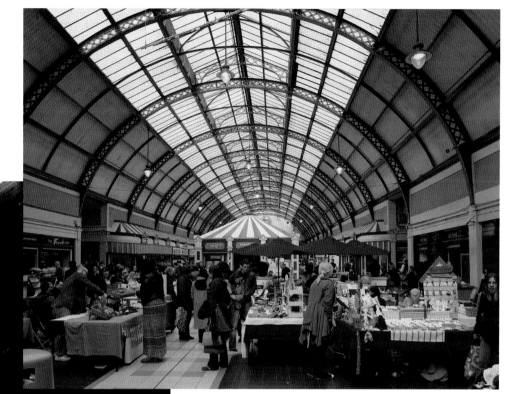

market constructed as a large, open-plan hall. In 1835, the opening ceremony was attended by over 2,000 people, and was followed by two grand dinners held within the vegetable market. The first cost five shillings (25p) and included wine, and the second included beer and cost two shillings (10p). The market boasted 243 shops, mostly butcher and vegetable stalls, and fourteen entrances from the surrounding streets. In 1895, a stall bearing the name Marks & Spencer opened, and it still remains to this day with the name Marks & Spencer's Original Penny Bazaar, making it not only the oldest remaining Marks & Spencer's outlet, but the smallest.

THE GRADE I LISTED Grainger Market is one of the UK's only remaining nineteenth-century covered markets still being used for its original purpose, although it is no longer used predominantly for selling meat and vegetables. Grainger Market has survived two world wars (an intact First World War shelter lies underneath the market) and the threat of demolition to make space for more modern shops. Today, it is it still popular, with over 200,000 shoppers visiting it each week.

GRAINGER STREET

GRAINGER STREET WAS opened in the 1830s and is named after Richard Grainger; entrepreneur, builder and developer of what is commonly referred to as Grainger Town. Between 1835 and 1842, Grainger, alongside architects John Dobson and Thomas Oliver, redeveloped an area in the centre of Newcastle covering 36 hectares, and some of the city's finest buildings and streets lie within this area. The architecture is often referred to as 'Tyneside Classical architecture'. It has been written of Richard Grainger that he 'found Newcastle of bricks and timber and left it in stone'. Grainger Street runs from the Grey's Monument and stretches down to Newcastle's Central Station. The south part of the street was pre-determined by the fifteenth-century St John's Church. It is the most southern section of Grainger Street that appears in this image (right) from 1897, on a busy day for the people of Victorian Newcastle. A smartly dressed man on a bicycle rides along the street. It is not surprising that this is the sole bicycle in the photograph, as they were very expensive; costing around £9 in an age when the average annual wage was £700.

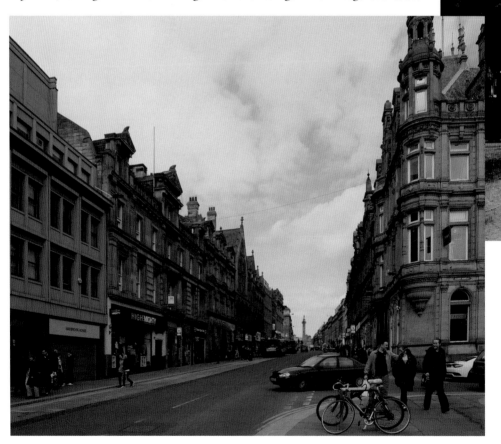

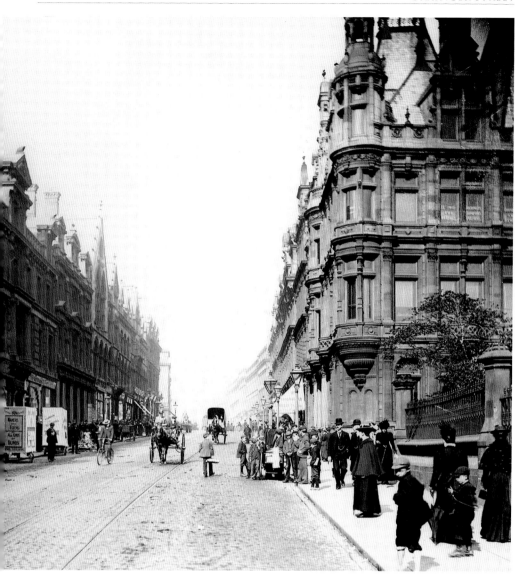

The building in the foreground on the right-hand side of the road was the Abyssinian Gold Jewellery Co. Ltd. Along the left-hand side of the street are two market stalls, one has 'Makers and Fixers of All Kinds of Blinds' printed on the side, and the other is the curiously named 'Human Restorers'.

GRAINGER STREET IN the twenty-first century remains architecturally stunning; a testament to the wonderful buildings that Richard Grainger introduced to the city all those years ago. The street remains, predominantly, a shopping street, with shops including the Cuban Cigar Club, High and Mighty (a clothes shop for men), and a Boots pharmacy. The building that was once the Abyssinian Gold Jewellery Co. Ltd is now Yates' Wine Lodge.

GREY STREET

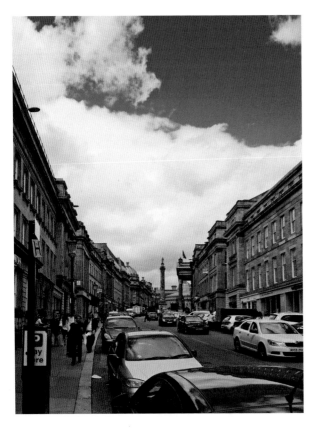

IN THE 1830s, Richard Grainger built Grey Street as part of his development of the city centre known as Grainger Town.

Originally, it was planned to call the street New Dean Street, as it runs to the south of Dean Street, which was constructed much earlier in 1749. However, with the building of Grey's Monument at the head of the new street, the name was quickly changed. The street was built on the route of the Lort Burn, which, at the time, was open to the elements and ran down to the Tyne. In order to build Grey Street, Grainger had to move the burn underground and fill its valleys with earth and rock to create a flattened surface to build upon. As a result, it is believed that some of the buildings along Grey Street have foundations as deep below ground as they stand above it.

This photograph (right) was taken in 1884, when thousands of people lined the street to celebrate the visit of the Prince and Princess of Wales, who had come to Newcastle to open Albert Edward Dock, Armstrong Park at Jesmond, and the Newcastle Reference Library. The arch was erected specifically for the event and was taken down afterwards. The Theatre Royal can just be seen through the arch on the right of the street, and in the far distance stands Grey's Monument.

IN RECENT YEARS the Grainger Town Partnership has done a remarkable job in restoring Grey Street, with the pavements being upgraded to Portland Stone. Most of the buildings remain unchanged and the street has become renowned throughout Britain for its Georgian architecture, leading to listeners of BBC Radio 4 voting it the 'Best Street in the UK' in 2002. Four times Prime Minister William Gladstone once described Grey Street as 'England's finest street', and Poet Laureate Sir John Betjeman summed the magnificence of Grey Street up perfectly when he said, 'As for the curve of Grey Street, I shall never forget seeing it to perfection, traffic-less on a misty Sunday morning. Not even Regent Street, even old Regent Street, London, can compare with that descending subtle curve'.

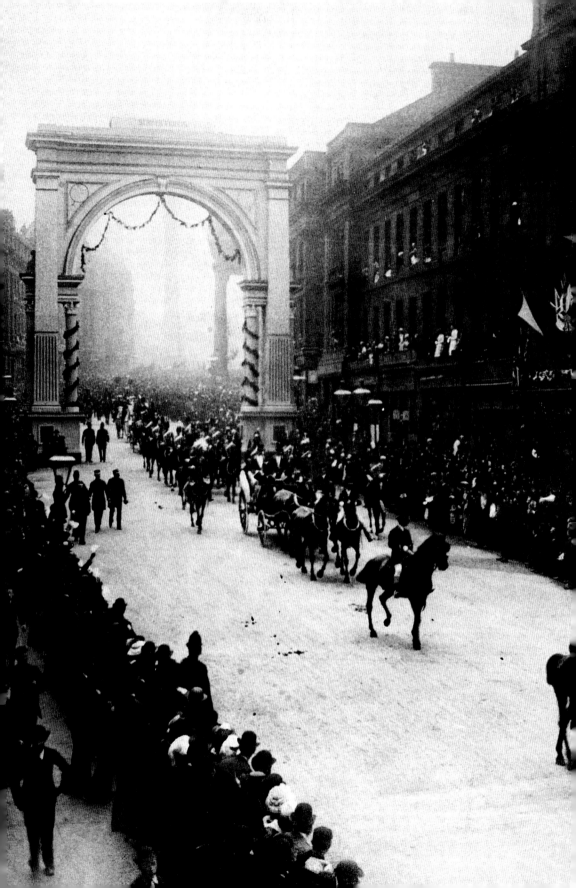

GREY'S MONUMENT

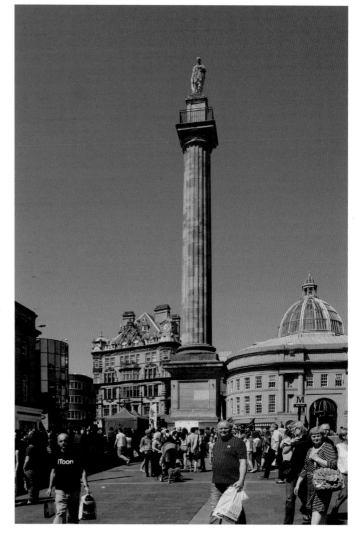

THE ONLY CHANGE to the monument during its almost 200-year history was brought about by an act of God. In 1941, a bolt of lightning struck the monument, knocking the Earl's head off, sending it smashing to the ground 134ft below. The fragments were safely stored for the duration of the Second World War, and, in 1947, sculptor Roger Hedley was employed to create a new head. By carefully gluing the pieces together and using this to create a plaster cast, he created the replacement head.

TODAY, EARL GREY is probably better remembered for the tea that bears his name, but the impact that Grey's Monument has had on Newcastle is clear to all; lending its name to Grey Street at the head of which it stands; Monument Metro station, a station on the Tyne and Wear Metro located directly underneath; and to the Monument Mall Shopping Centre. The surrounding area is simply known as Monument. Originally, the monument stood on a traffic island, but the area around the monument is now completely pedestrianised, and the wide base of the monument is a popular meeting place and often acts as a venue for buskers, religious speakers, and political protesters. The 164-step spiral staircase within the column, which leads to a viewing platform at the top of the monument offering an unrivalled view across the city of Newcastle, is occasionally opened to the public.

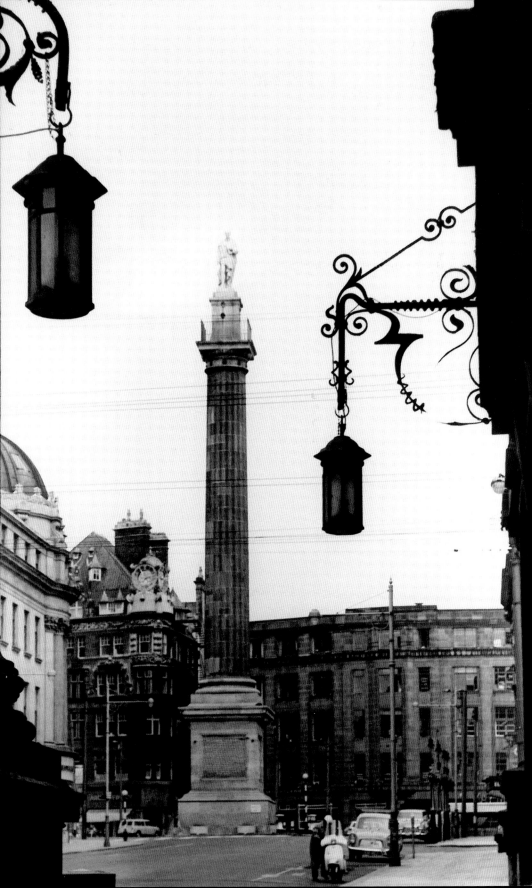

THE HIGH LEVEL BRIDGE

PICTURED BELOW IN around 1880, the High Level Bridge is a road and railway bridge spanning the River Tyne. The photograph is taken from the Gateshead side of the river, with the Castle Keep and St Nicholas' Cathedral dominating the skyline on the Newcastle side. Designed by Robert Stephenson and constructed between 1847 and 1849, it was built for the York, Newcastle and Berwick Railway at a total cost of £491,153. It was the first major example of a

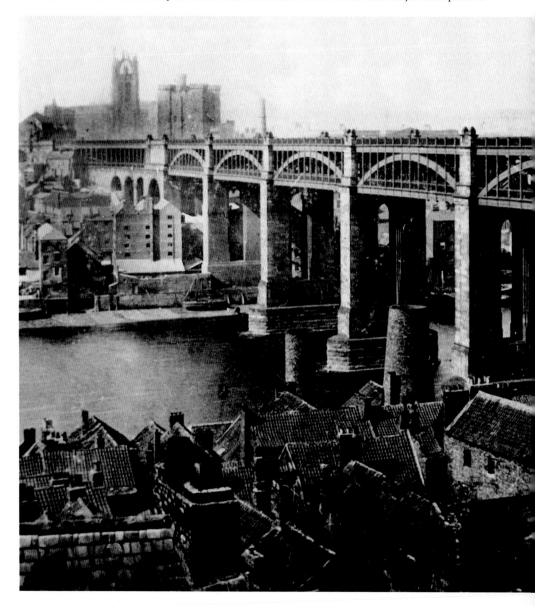

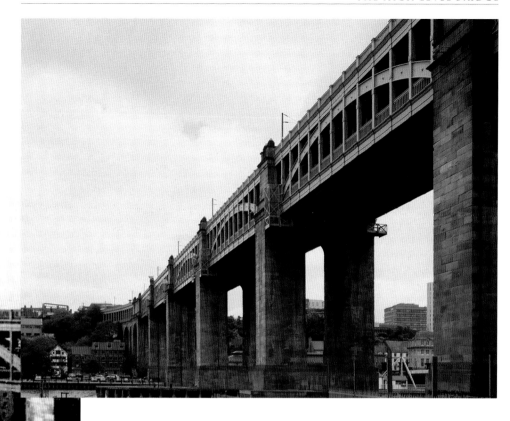

wrought-iron bow-string girder bridge and provided a double deck, with railway traffic on the top level and road traffic below. It was opened to rail traffic on 15 August 1849, with an official opening ceremony by Queen Victoria on 27 September. The lower level was opened the following year, on 4 February 1850. When both Newcastle and Gateshead were devastated by the Great Fire of 1854, locals flocked to the new bridge, which commanded an unrivalled view as the flames consumed the towns below. It was written in *The Illustrated London News* at the time that the High Level Bridge provided an excellent vantage point but 'began to vibrate like a piece of thin wire'.

SINCE ITS CONSTRUCTION in 1906, the King Edward VII Bridge, just to the west of the High Level Bridge, has taken over as the Edinburgh-London East Coast main line, leaving the High Level Bridge to provide a route for local trains going to Sunderland and Middlesbrough, and the Leamside line. In recent years, the bridge has undergone extensive yet essential maintenance, which resulted in it being closed off to road traffic from February 2005. Work included the need to replace timber supports, and the repair of severe cracks found in some of the iron girders. Extra crash barriers were added to both sides of the roadway, which has left space for only one lane of traffic. Since re-opening in June 2008, the bridge now only carries south-bound road traffic, specifically only buses and taxis.

THE HOLY JESUS HOSPITAL

SINCE 1291, THERE had been an Augustinian friary standing upon the site of the Holy Jesus Hospital. In 1539, the friary was seized by the Crown, along with five others in the area, including the Dominican monastery of Blackfriars. In 1681, the Holy Jesus Hospital was built to house retired freemen, their widows and their unmarried sons and daughters. Initially, the hospital did not have a name and was commonly known by local people as the 'Town's Hospital', but three years after it was constructed it was given the name of the Holy Jesus Hospital. The building itself was constructed using brick, which was, at that time, a relatively new method – brick was normally used as an infill for timber-framed buildings. Up until 1880, a police station had adjoined the hospital on the west side, but was replaced with a soup kitchen. It was funded by public subscription and dispensed soup to the 'deserving poor' until 1891. During the winter months, there was often up to 800 people

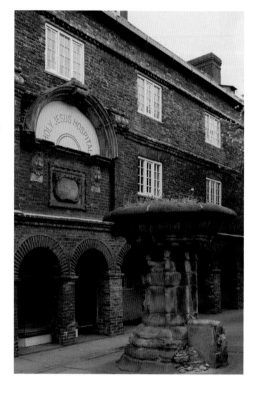

queuing at the back of the building. This photograph (right) of the Holy Jesus Hospital was taken the year following the opening of the soup kitchen. The soup kitchen closed in 1891, after which it was leased to a butcher and then a chemicals company. The Holy Jesus Hospital closed in 1937.

DESPITE BEING LEFT empty, the Holy Jesus Hospital has fortunately survived the extensive redevelopment of the city during 1951, and also in 1963 – the year in which the Royal Arcade was pulled down to make way for Swan House. This left the Holy Jesus Hospital and nearby Alderman Fenwick's House in Pilgrim Street as the only seventeenth-century brick buildings remaining in Newcastle. In the late 1960s, the Museum Board chose the Holy Jesus Hospital to be restored and opened as it a museum. However, the building had stood derelict for so long that the resulting restoration costs were estimated at £67,000. By August 2004, £800,000 had been spent on renovating the building, which currently functions as a working office. The site of the hospital has been helping the people of Newcastle for over 700 years, and that continues to this day – serving as it does as the base of the Inner City Project of the National Trust, which has been running since 1987. This project takes people between the ages of 12 and 25 and the over 50s out into the countryside, in order to increase appreciation for the city's natural surroundings.

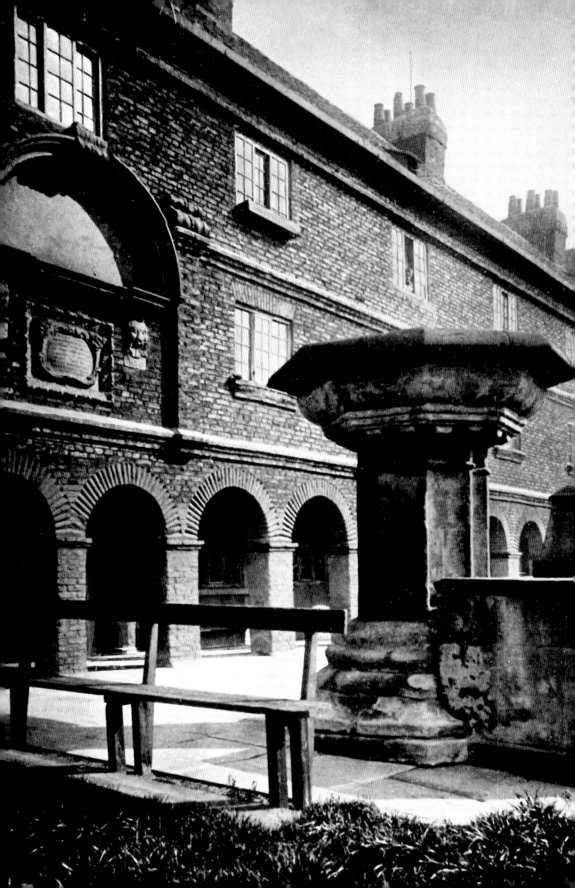

JESMOND DENE

JESMOND DENE IS a public park in the east end of Newcastle, and occupies the narrow valley of the Ouseburn River. Dene is a word commonly used in the north-east to describe such valleys. The park was first laid out in the 1860s by William George Armstrong and his wife Margaret, who bought Jesmond Dene House in 1857. As with their magnificent home of Cragside, just outside Rothbury, the design is intended to reflect a rural setting, with exotic shrubs, crags, waterfalls and miles of footpaths intertwined within the lush woodland. In 1883, Lord Armstrong presented the park that he'd created – and named Armstrong Park – to the Corporation of Newcastle to be enjoyed by the local people. It was officially opened the following year by the Prince and Princess of Wales. This photograph (right), taken in 1860, shows the old mill within Jesmond Dene. The current listed building dates to before 1820, and stands upon the site of an earlier mill. Although still inhabited until the 1920s, milling ceased here sometime between the 1860s and 1890s. It was repaired and remodelled but is now a ruin.

THE IRON-CONSTRUCTED Armstrong Bridge spans the Dene and is now closed to road traffic. From the 1990s through to 2011 the park was used to host a crafts fair every Sunday morning. Jesmond Dene also contains a free entry petting zoo known as 'Pet's Corner', which has been a popular family attraction since the 1960s and was redeveloped in 2011. Opposite is the Visitors' Centre, providing information on the wildlife and the other attractions within Jesmond Dene, and which has a coffee shop, a conference centre and a restaurant.

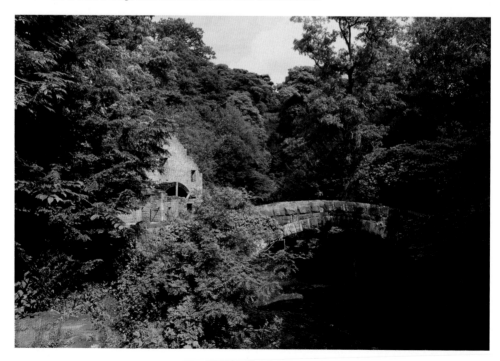

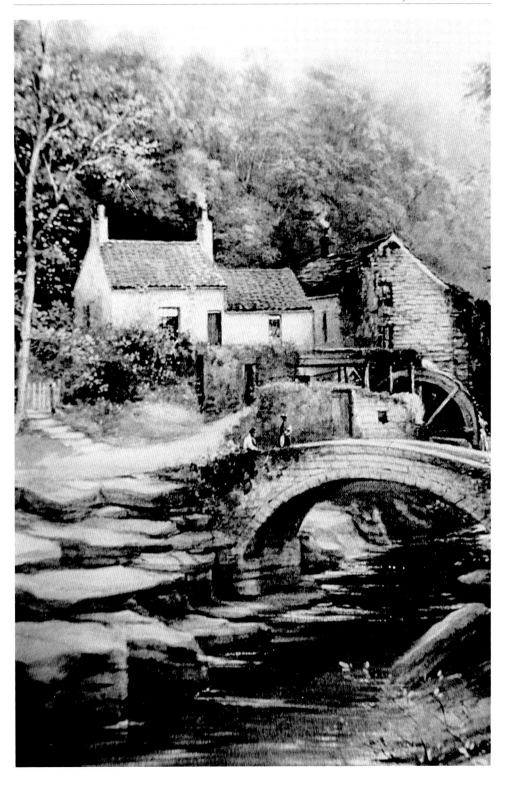

THE KEELMEN'S HOSPITAL

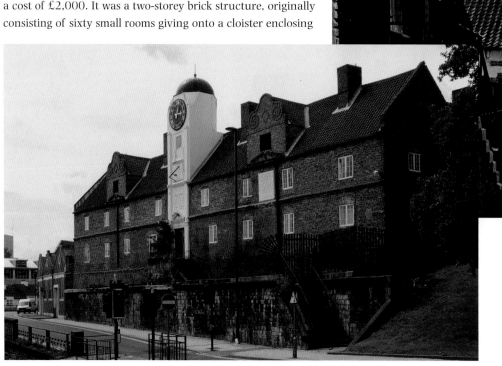

KEELMEN WORKED ABOARD the keels – large boats that carried
the coal from the banks of the River Tyne and the River Wear
to be loaded onto waiting collier ships. The shallowness of both
rivers made it impossible for the larger ships to move up river to
collect the coal without running aground. The answer to this
was the shallow-draught keels. The keelmen forged a close-knit
bond on both rivers, until late in the nineteenth century, when
the keels were no longer needed. A keelman's life was harsh
and involved hard physical labour, with most of them being
unable to work beyond forty years old, so, in 1699, the keelmen
of Newcastle decided to construct a charitable hospital, or
almshouse, 'for poor keelmen and keelmen's widows'. The
keelmen agreed to contribute fourpence per tide from the wages
of each keel's crew, and the Newcastle Corporation made land
available in Sandgate. The hospital was completed in 1701 at
a cost of £2,000. It was a two-storey brick structure, originally
consisting of sixty small rooms giving onto a cloister enclosing

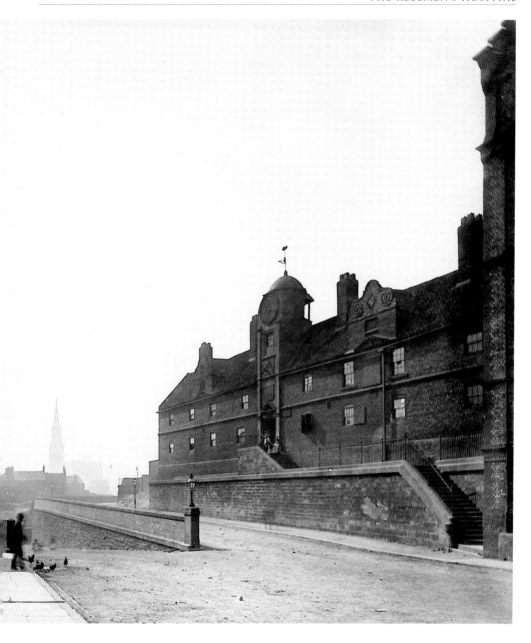

a grass courtyard, at an annual rate of a shilling per room. Shortly after its completion, a visiting bishop remarked that he 'had seen many hospitals, the works of rich men, but it was the first he ever saw or heard of which had been built by the poor'.

THE GRADE II LISTED Keelmen's Hospital remains in City Road today, and, until recently, accommodated university students in enlarged and modernised rooms. The building is currently empty.

LAING ART GALLERY

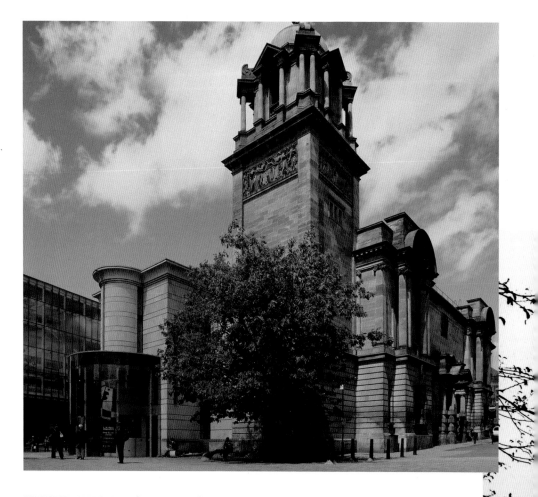

SITUATED ON NEW Bridge Street in the centre of Newcastle, Laing Art Gallery (pictured on the right in 1920) was founded in 1901 by Alexander Laing, a wealthy Scottish merchant who had successfully ran his own bottling company before branching out into wines and spirits. In 1899, the Newcastle Council was conscious of the city's lack of an art gallery, but struggled to raise funds to provide one. Laing wanted to give something back to the city in which he had made his fortune, and in 1900 offered £20,000 to the council to fund the project, which they graciously accepted. In 1901, the foundation stone was laid by Mrs Watson-Armstrong, and this was followed by a celebratory lunch at the Great Assembly Rooms. The building of the magnificent gallery took three years, costing Alexander Laing 50 per cent more than originally estimated. When the doors of Newcastle's first art gallery opened to the public in 1904, the exhibition of British paintings, work by local artists, and world cultures, proved so popular that the police had to be called to control the excited crowds.

THE LAING ART Gallery is now managed by Tyne & Wear Archives & Museums. It is home to an impressive collection of eighteenth- and nineteenth-century paintings and internationally important watercolours. Northern Spirit, a major new permanent exhibition celebrating the achievements of artists, manufacturers and makers from the North East of England, opened in October 2010, and features internationally acclaimed art including work by nineteenth-century painter John Martin, engraver and naturalist Thomas Bewick and the Beilby family of glass enamellers. Its regularly rotated exhibition programme is renowned for bringing the biggest names in historic, modern and contemporary art to the North East. Visitors to the Laing Art Gallery will cross the Blue Carpet – a piece of installation art – in the square outside. It was designed by Thomas Heatewick and took six years to complete, opening in 2001. The square is covered in a skin of blue paving slabs, made by encasing crushed blue glass within resin. There are a number of benches that appear to fold up from the carpet surface, and beneath the benches are coloured lights. At the points where this carpet reaches an obstacle, such as a building, the slabs curve upwards to create the illusion that the tiles are a fabric laid over the area. The Laing Art Gallery is open seven days a week and entry is free. The building to the left of the gallery was demolished in 1970 to make way for John Dobson Street.

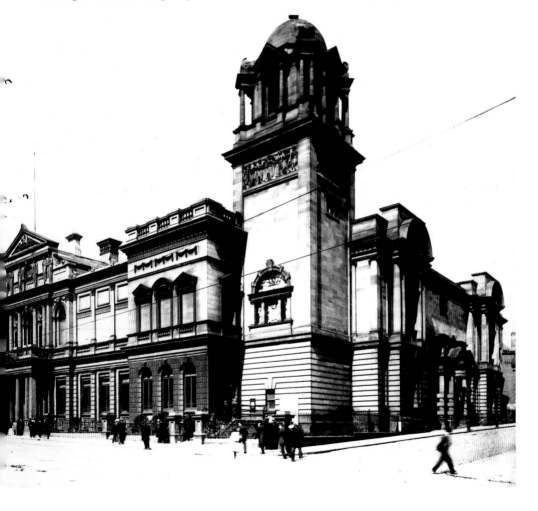

LEAZES PARK

THE PHOTOGRAPH BELOW shows Leazes Park, Newcastle's first public park, in around 1910. The Royal Victoria Infirmary can be seen in the background. The need for 'ready access to some open ground for the purpose of health and recreation' was brought to the attention of Newcastle Council in September 1857, when 3,000 local working men came together and formed a petition. The council agreed, and within twelve months a committee was formed with the aim of finding a suitable location for what would be the city's first public park. This was a long-drawn-out process, and on 23 December 1873 Leazes Park was officially opened

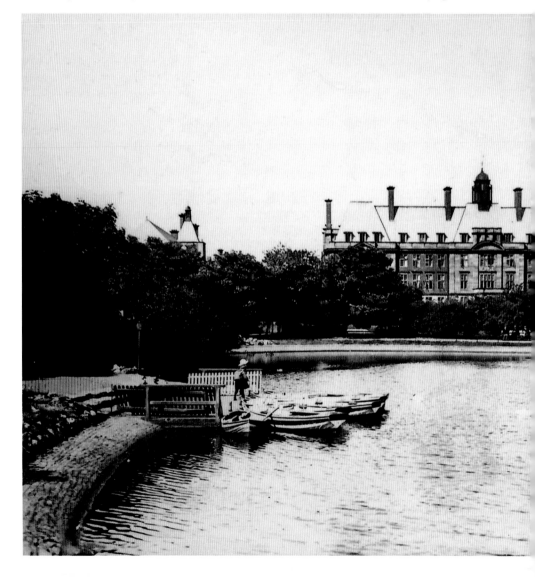

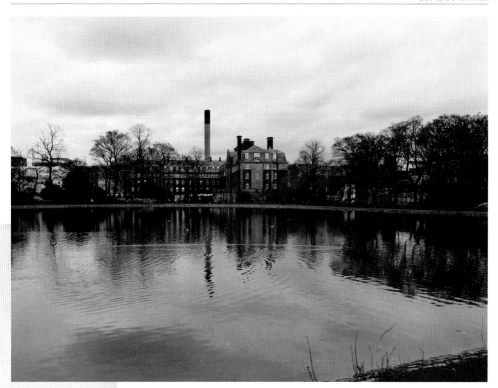

for the people of Newcastle by Alderman Sir Charles Hamond. The Town Surveyor, John Fulton, designed the park around the lake, which was created on the line of the Lort Burn – which had flowed through the centre of the city until 1696, when it was covered over. Work on the park continued once the park had opened, with a bandstand and terrace being added. The grand Jubilee gates were added in 1897 to commemorate the Diamond Jubilee of Queen Victoria. In 1905, a bust of Sir Charles Hamond was erected, and with this, the park was finally considered to be complete, over thirty years after it opened.

BY THE 1980s the park had tennis courts and croquet lawns, and there were even deer roaming around! However, it was accepted that the park had become run down and was in dire need of restoration. In 2001, the Heritage Lottery Fund awarded a £3.7 million grant to make this possible. Restoration included the reintroduction of ornate gateways and boundary railings based on original designs, and the lake has been restored with drainage improvements. These days, the park is a wonderful place for residents and visitors of the city, whether it be to take a walk around the lake and feed the ducks and swans, or to partake in tennis, bowls, or fishing – the lake being home to many species of freshwater fish, and renowned for its large carp.

THE LITERARY AND PHILOSOPHICAL SOCIETY

THE LITERARY AND Philosophical Society of Newcastle-upon-Tyne (commonly shortened to the 'Lit & Phil') was founded early in 1793 as a 'conversation club' for men, with an annual subscription of one guinea. Due to the society's broad-minded outlook they were breaking new ground from the outset; with women being allowed to join in 1804, a demonstration of George Stephenson's miner's safety lamp in 1815, and, in 1820, a controversial new society was established as a result of one of the meetings held in the society's rooms: The Newcastle-upon-Tyne Society for the Gradual Abolition of Slavery in the British Dominions. The Lit & Phil had their own building, designed by John and Benjamin Green, and the foundation stone was laid by the Duke of Sussex in 1822. Building work was completed in 1825. The society continued to welcome demonstrations of new revolutionary technologies, and on 20 October 1880 the society's lecture theatre was the first public room to be lit by electric light, during a lecture by Sir Joseph Swan – who would later become president of the society in 1911. For over 200 years the society has continued to grow, with many tens of thousands of people passing through the doors. Some of the more

notable members of the Lit & Phil include architects John Dobson and Richard Grainger, former Prime Minister Charles Grey, 2nd Earl Grey, and Pet Shop Boy Neil Tennant.

THE LIT & PHIL is a Grade II listed building, and the beautiful reading rooms remain largely unchanged. It houses the largest independent library outside London, with over 150,000 books, including a vast selection of current fiction and non-fiction titles covering every field of interest. The music library is without equal in the North of England, including 8,000 CDs and 10,000 LPs. In addition to the library, the society hosts a wide range of events open to members and non-members, including book launches, lectures, and readings.

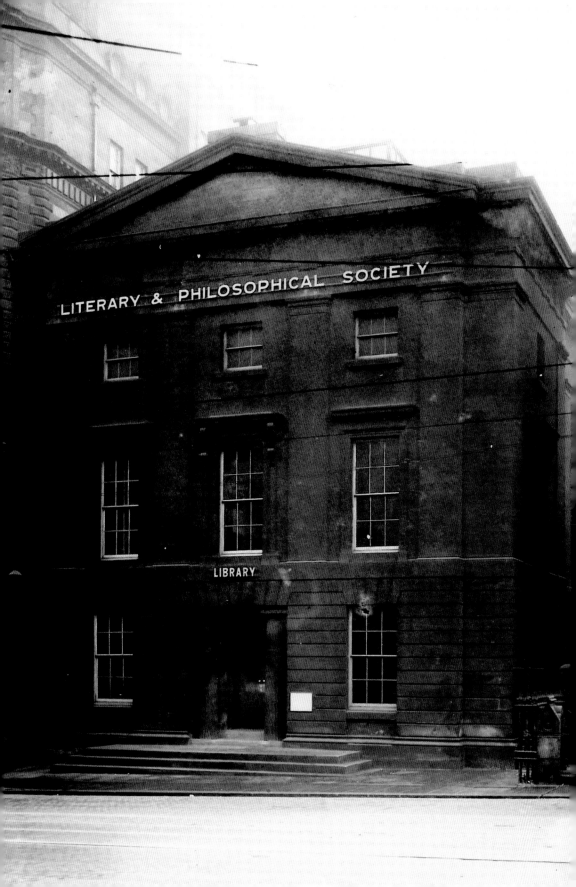

MILL VOLVO TYNE THEATRE

PICTURED ON THE right in 1900, the Mill Volvo Tyne Theatre and Opera House is one of the region's most popular live entertainment venues, and the oldest working Victorian theatre in the world. The theatre was designed by William B. Parnell and was opened on 18 September 1867. It became a roaring success, rivalling the Theatre Royal for decades in its productions. However, in the years leading up to the First World War it faced difficult times, and, reluctantly, it was forced to accept moving pictures on occasion. In April 1913, a projection box of steel plates was constructed backstage. This rear projection approach meant the auditorium did not have to be altered, and the hope was that it could easily revert back to theatre use. In 1919, it was closed for renovation and modernisation and re-opened as the Stoll Picture Theatre, and the sign which remains today was added to its frontage. In 1929, the theatre's reputation was further enhanced when it became the first venue in Newcastle to show a 'talking picture'. During the 1960s, the theatre fell upon hard times and began to put on X-rated movies; this continued until 1974,

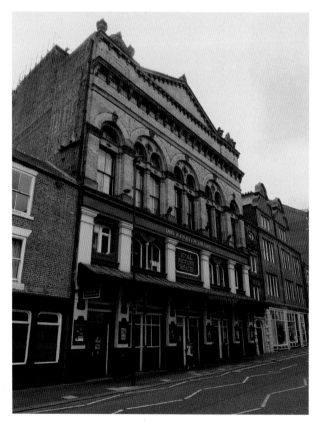

when it was forced into closure. It re-opened in 1977, restored to put on theatre productions once more, and hasn't looked back since – the only setback coming when fire broke out on Christmas Day 1985 and the building was seriously damaged.

TODAY, IT REMAINS, substantially, as it had been when it first opened, including the wonderful acoustics, which are a result of the walls being lined with wood. The beautiful Grade I listed building can seat 1,100 people, and plays host to an assortment of events, from opera and theatre shows, comedy and pantomimes, to concerts to conferences.

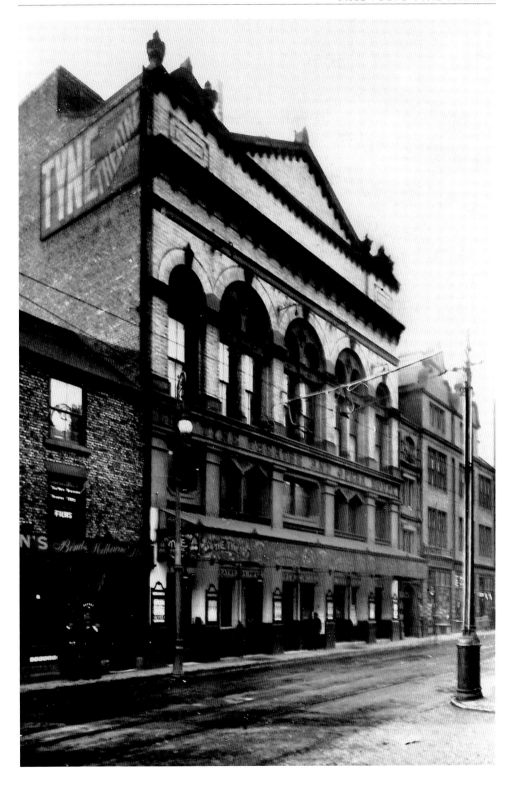

MOOT HALL

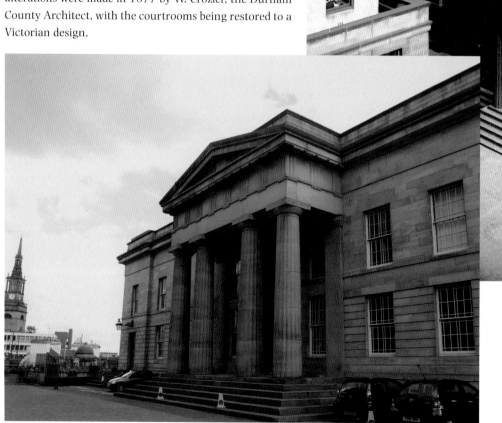

DURING 1809, THE Castle Keep was purchased by the
Newcastle Corporation and the private dwellings and
shops within the castle boundaries were demolished to
make way for the building of Moot Hall – 'Moot' is an old
English word meaning meeting. These law courts were
built in 1811 by John Stokoe (although contemporary
accounts refer to William Stokoe, all elevated drawings
are signed John Stokoe) in a 'Greek Revival' style of
architecture, with it being described upon its completion
as the most perfect specimen of Doric architecture in the
North of England. The Moot Hall has a columned portico
to the front, whilst the design of the rear is based on the
Parthenon in Athens. The building served as the Crown
Courthouse, used for criminal and civil cases. Further
alterations were made in 1877 by W. Crozier, the Durham
County Architect, with the courtrooms being restored to a
Victorian design.

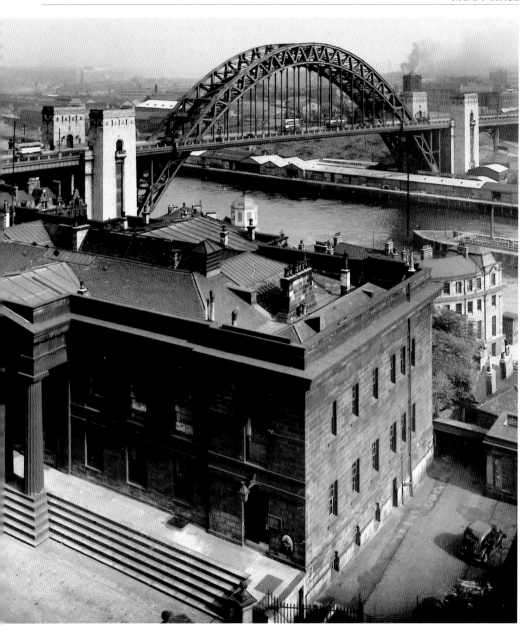

THE MAGNIFICENT GEORGIAN building stands as proudly today as it ever did. It was the first court in the country to be licensed to hold civil weddings and civil ceremonies, and with the chandelier-lit Grand Jury Room offering breathtaking views across the Tyne, it is easy to see why this would prove a popular wedding venue. Moot Hall has been used as an overflow court since the opening of the Quayside Law Courts, and the two traditional oak courtrooms, dating from 1875, still have trapdoors in the docks leading down to the cell area, with huge studded doors and manacles still attached to the cell wall.

NEWCASTLE GUILDHALL

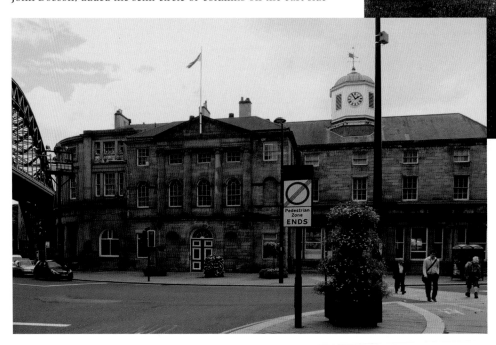

THE FIRST NEWCASTLE Guildhall was built in 1235 on a site next to the busy quayside, and it was in this year that Henry III granted permission for the townsfolk to form a Merchant Guild, recognising Newcastle's status as an expanding market town. The Merchant Guild controlled the way in which trade was conducted in the town, and as a result quickly became the most powerful economic and political force in Newcastle. When a town council was established much later, the guild's influence and importance was greatly diminished, but the meeting place of the town council has continued to be called a Guildhall, rather than a Town Hall.

TODAY'S GUILDHALL WAS built slightly south of the original hall. It was rebuilt and enlarged in the 1650s by Yorkshire architect Robert Trollope, who, in 1658, designed the grand interior which remains almost in its entirety today. In the nineteenth century the exterior undertook a major overhaul, when Newcastle's famous architect, John Dobson, added the semi-circle of columns on the east side –

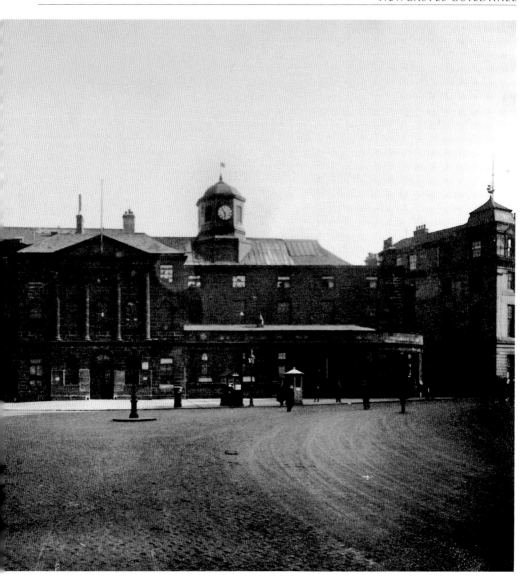

they were built to support a portico, offering shelter to a fish market. Still a beautiful building, the Guildhall houses a newly opened tourist information centre, with a Victorian Minton floor depicting the history of Newcastle. It was installed in the 1850s, at which point the building was used as a magistrates' court, but had been covered up for decades before being uncovered by builders in 2008. The upper floors of the building are not open to the public, and as a result are undoubtedly Newcastle's best kept secret. It was the place of the original assizes, and is complete with shackles for prisoners; there is also the seventeenth-century Merchant Venturer's Court. Newcastle Guildhall takes part in the city's annual Open Heritage Days, offering visitors the rare opportunity to explore the entire building.

NEWCASTLE UNIVERSITY, ARMSTRONG BUILDING

NEWCASTLE UNIVERSITY BEGAN life as the School of Medicine and Surgery in 1834 (later the College of Medicine), when it provided practical demonstrations and basic lectures to twenty-six students. Attempts to realise a place for the teaching of sciences in the city were finally met with the foundation of the College of Physical Science in 1871, offering instruction in mathematics, chemistry, physics, and geology (to meet the growing needs of the mining industry), this was later renamed Armstrong College. It became the University of Newcastle-upon-Tyne by an Act of Parliament in August 1963. The 50-acre university campus is situated close to the Haymarket in the city centre, between the green spaces of Leazes Park and the Town Moor.

The oldest building on the campus is the Armstrong Building (pictured on the right in 1966) and is the site of the original Armstrong College (named after William George Armstrong, a local industrialist who founded the Armstrong Whitworth manufacturing empire). It was built in three key phases; the north-east wing was completed in 1888 and cost £18,000. It was opened by Princess Louise, Princess Royal and Duchess of Fife, on 5 November 1888. The south-east and south-west wings were opened in 1894. The south-east wing includes the Jubilee Tower, which was built with surplus funds raised from the Jubilee Exhibition at the nearby Town Moor Recreation

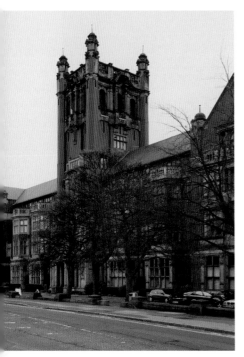

Ground (now named Exhibition Park) to mark Queen Victoria's Jubilee in 1887. The north-west front, forming the main entrance, was completed in 1906 and features two stone figures representing science and the arts. Much of the later construction work was financed by Sir Isaac Lowthian Bell, the former Mayor of Newcastle, for whom the main tower is named. It was opened by King Edward VII in 1906.

THE ARMSTRONG BUILDING contains the King's Hall, named after King Edward VII, who granted permission to name the Great Hall after him. This serves as the university's chief hall for ceremonial purposes and where congregation ceremonies are held. In 1949 the University Quadrangle, next to the Armstrong Building, was turned into a formal garden in memory of members of Newcastle University who gave their lives in the two world wars. Today, Newcastle University is one of the top universities in the country; ranked 9th in the UK by Webometrics Ranking of World Universities, and in 2011 was rated the 127th best university in the world by QS World University Rankings.

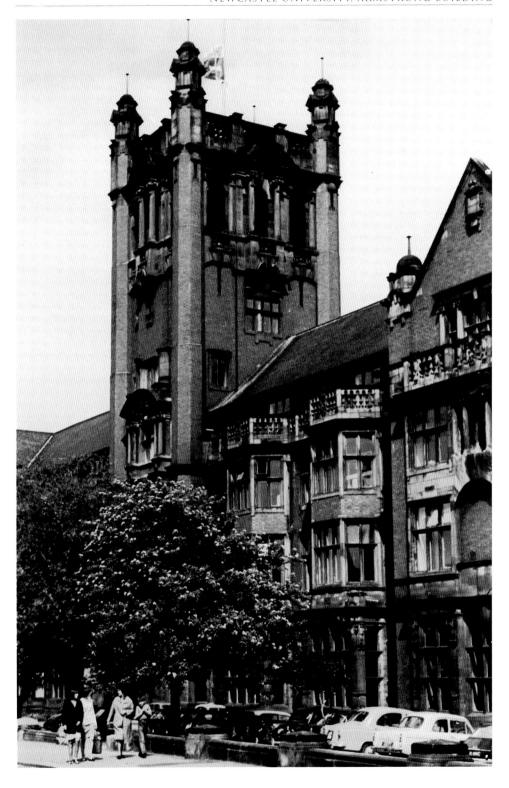

NORTHUMBERLAND STREET

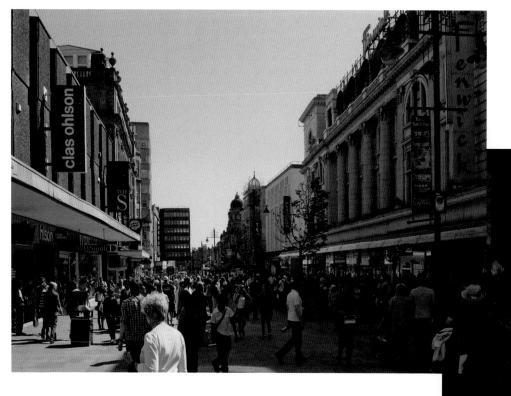

NORTHUMBERLAND STREET IS the main shopping street in Newcastle, and is thus named because it was the direct route to Northumberland for most of Newcastle's existence; it is now pedestrianised. By 1736 it was described as 'a very well built street, having in it some very pretty houses standing in the middle of gardens and shady fields'. The pivotal moment which transformed the street's primary function was the opening of J.J. Fenwick's ladies' outfitters shop in 1882, with a staff of two. It moved to its current location in 1885, and by 1914 had grown substantially with 400 people in its employ. It was Fred Fenwick, J.J. Fenwick's son, who transformed the shop into a department store. This increased the flow of customers hugely, with around 295 people passing through their doors each day. This image of Northumberland Street from 1903 (right) shows elegantly dressed Edwardian men and women passing the Cosy Corner Café to the front left of the photograph. The trams, which started running in 1901, made Northumberland Street easily accessible to all. With over 350 trams a day passing along the street, they definitely played a vital role in helping shops on the street to thrive.

NORTHUMBERLAND STREET HAS continued to grow and improve, and is today the most expensive location to own a shop outside of London's Oxford Street. There are over fifty retailers on the street, and Fenwicks, the store which started it all, now gets on average 3,000 shoppers daily. Long gone are the tramlines, and since 1999 the entire street has been pedestrianised; it is even closed to cyclists and skateboarders. Sadly, the grand Georgian and Victorian buildings, which can so clearly be seen in the earlier photograph, have largely gone; a large section where HMV, JD Sports, and Currys currently occupy was demolished after being damaged beyond repair in a fire in December 1969. Other buildings have been remodelled as the street has grown, to provide additional shop floor space. That's not to say that evidence of earlier times cannot be seen in the street's architecture; the beautiful building, which currently houses Superdrug, dates from 1880, and a stunning building halfway down the street on the west side, home to Zara ladieswear (originally built as a Boots and Co. in around 1900), has an amazing top two storeys, with classical stonework and four life-sized figures – all linked to the city's past – looking down on the modern-day shoppers going about their busy days.

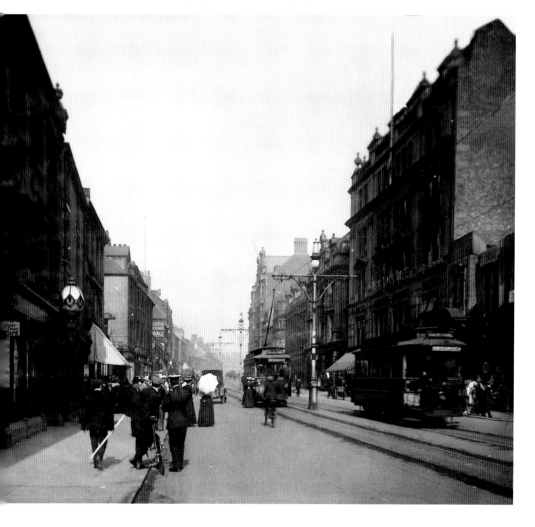

ST MARY'S CHAPEL

THE OLDEST CHURCH or chapel in Newcastle are the ruins of St Mary's Chapel (pictured on the right in 1903) in Jesmond Dene. Found on a small copse formed by the course of the Moor Crook Letch, the chapel was originally built in the twelfth century by the Grenville family, one time Lords of Jesmond, who brought relics from the Holy Land to the chapel, resulting in it becoming the object of pilgrimages. (Pilgrim Street in the city centre is so named because the pilgrims would lodge there on their way to St Mary's.) Between AD 1125 and AD 1250, the chapel became one of the most important shrines in Christendom because of miracles reputed to take place among the sick who attended the chapel and the Holy Well nearby, in a wooded hollow. There was so much evidence for these miracles, that the Pope in Rome accepted the healing powers of the chapel and well. It was written that these miracles were the work of the Holy Ghost of Jesus, at the request of the Virgin Mary.

By 1428 the chapel had become partly ruined and, due to the religious importance of the shrine, Pope Martin declared that it should be repaired. Indeed, the chapel was so significant that the King of England attended to make presentations annually until 1449. By 1548, records show that the chapel was no longer in use, and in 1549 the Mayor of Newcastle paid £144 13s 4d to Edward VI to purchase the chapel and the adjoining hospice. It passed through several

private hands in the centuries to follow, with the chapel being dismantled and put to more earthly uses; it was a hospital, and then a family home, before eventually becoming a barn and stable. It was a ruin by 1883, when it was returned to the people of the city by Lord Armstrong as part of his gift of Jesmond Dene to Newcastle for a public park.

ALTHOUGH ST MARY'S Chapel today remains as a roofless ruin, surrounded by tall trees and with wild flowers growing within its ancient stone walls, it is still a place of worship to many who come to pray, maintain the site, and leave offerings. The Holy Well of St Mary's is also popular with visitors and can be found nearby on the footpath behind Grosvenor Road.

PLUMMER TOWER

DURING THE THIRTEENTH and fourteenth centuries a town wall was built to help defend the town in times of conflict. It covered a distance of over 2 miles, was at least 2 metres thick, and over 7.5 metres high. It was built with six main gates: Close Gate, West Gate, New Gate, Pilgrim Gate, Pandon Gate and Sand Gate. It also had seventeen towers, as well as several postern gates. Throughout the border wars, with the constant threat of invading Scottish armies, the wall was well maintained. As the strategic importance of the wall declined, it was allowed to fall into ruin, and, during the eighteenth century, much of it was demolished, with stone being used on other buildings within the city.

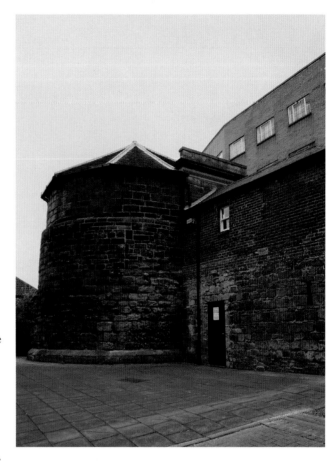

One of the seventeen towers along the wall is now incorporated within Plummer Tower, named as such because it was paid for by the Plummer family, a prominent merchant and political family in Newcastle. The wall sections either side of the tower were removed in 1811, and the tower was used by the Company of Cutlers as a meeting room. In the 1740s, it was let to the Company of Masons, who built an upper storey and the western façade with its classical detailing, including an elaborate Venetian window. Following the extinction of the family, the tower has had many different purposes – in this photograph (opposite), taken in 1885, the tower was being used as a family dwelling. It remained this was until 1915, when the tower was restored and adapted for use as a workshop by Gardener and Nicholson, picture-frame makers.

THE MODERN DAY city of Newcastle has grown around Plummer Tower, which stands opposite the Plummer House office block. In 1971, Plummer Tower was awarded Grade I listed status. It is currently used as offices.

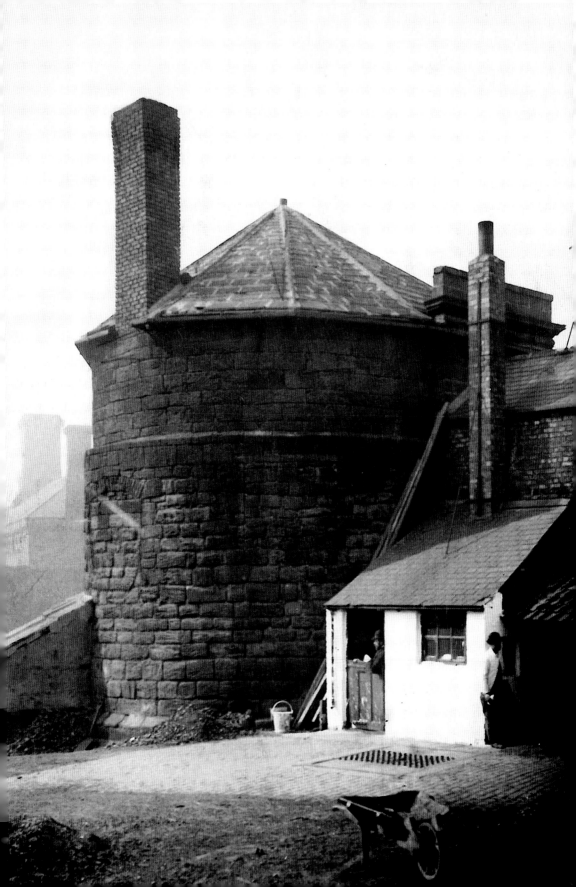

ROYAL VICTORIA INFIRMARY

IN 1897, A decision was made to construct a new hospital for Newcastle to replace the existing hospital at Forth Banks (founded in 1751), and to commemorate the year of Queen Victoria's Diamond Jubilee. The sum of £300,000 was raised towards the building of the hospital, and the Corporation and Freemen of Newcastle provided 10 acres of land on the Castle Leazes Moor. Building commenced in 1900 and took six years. On 11 July 1906, King Edward VII opened the Royal Victoria Infirmary, and also unveiled a statue of his mother, Queen Victoria, for whom the hospital is named, and who had died during the construction of the building in 1901. The over-life-size white marble statue stands atop a white pedestal and is 22ft tall. It depicts the young Victoria in robes, with an orb, sceptre and crown. It was the gift of Sir Riley Lord, knighted for his efforts in getting the hospital built.

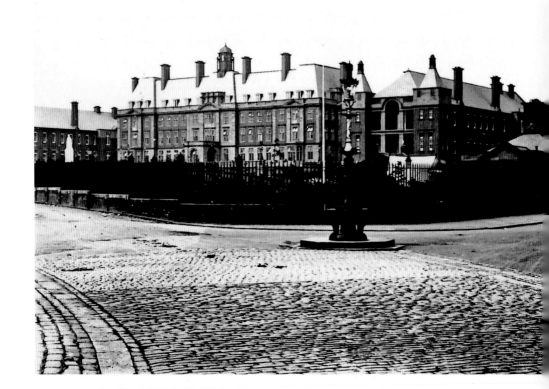

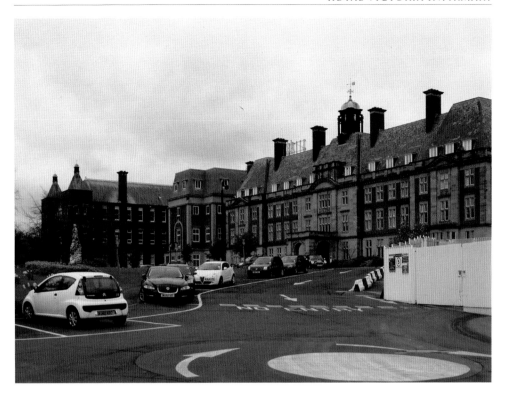

Expansion and improvements were almost immediately necessary, and finding funds to complete the work was problematic, especially during the depression years. Overcrowding was also an issue, and in 1917 an Act of Parliament was passed allowing three pavilions to be constructed temporarily nearby to treat those injured in the First World War. Overcrowding continued into the 1930s, with up to 5,000 people seeking medical care. This problem eased somewhat when the Royal Victoria Infirmary joined the National Health Service in the early 1930s. In 1933, a new block was added with an operating theatre, an out-patients department, and forty-eight beds.

FOR WELL OVER 100 years, the Royal Victoria Infirmary has cared for the people of Newcastle and continued to grow, adapt and keep up to date with continuous advancements in medical practise and technologies. It has close ties with the Faculty of Medical Sciences at Newcastle University and is a leading teaching hospital. The Royal Victoria Infirmary is one of the four clinical base units where students spend the entire third and fifth years of their medical degree. Since 1998, the Royal Victoria Infirmary has been managed by the Newcastle-upon-Tyne Hospitals NHS Foundation Trust. The Trust is currently embarking on a major project transforming the Newcastle Hospitals, which sees the hospital currently undergoing a mammoth program of redevelopment.

SIDE

SIDE IS NOT only one of the shortest street names but also one of the few remaining medieval streets in Newcastle, and, until Dean Street was built in the 1780s, it was the main route from the riverside to the higher part of town. According to historian John Brand, the street got its name because it is a route down the side of a hill and because it is by the 'side' of the castle.

Side was home to a number of public houses, and the Burns Tavern can be seen in the picture below, taken in the 1870s. To the left of the image is where Amen Corner meets Side. The clergy from St Nicholas' Cathedral would hold a procession around the outside of the

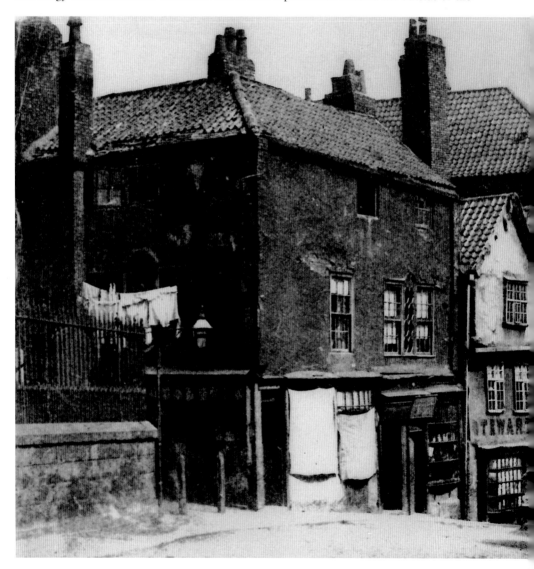

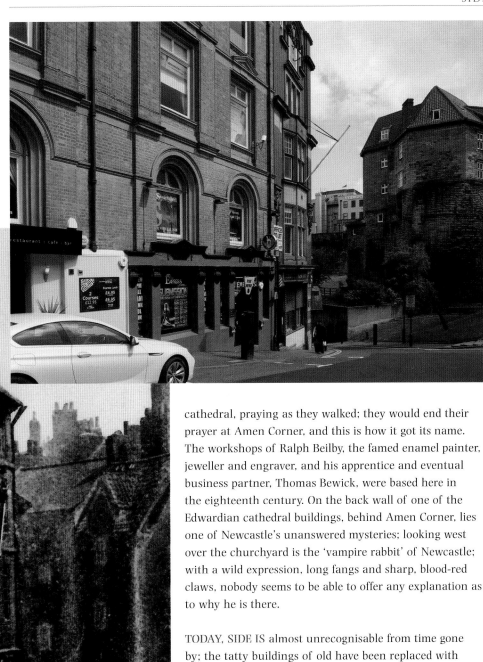

cathedral, praying as they walked; they would end their prayer at Amen Corner, and this is how it got its name. The workshops of Ralph Beilby, the famed enamel painter, jeweller and engraver, and his apprentice and eventual business partner, Thomas Bewick, were based here in the eighteenth century. On the back wall of one of the Edwardian cathedral buildings, behind Amen Corner, lies one of Newcastle's unanswered mysteries; looking west over the churchyard is the 'vampire rabbit' of Newcastle; with a wild expression, long fangs and sharp, blood-red claws, nobody seems to be able to offer any explanation as to why he is there.

TODAY, SIDE IS almost unrecognisable from time gone by; the tatty buildings of old have been replaced with modern structures housing popular restaurants, bars and shops. G. Scott gentleman's hairdressing stands proudly where Burns Tavern did many years ago, and the popular Empress Bar is conveniently situated between Newcastle's Bigg Market and the Quayside – Newcastle's two main nightlife hotspots.

THE PARISH CHURCH OF ST ANDREW

THE PARISH CHURCH of St Andrew, pictured on the right in 1890, on Newgate Street is believed to be the oldest church still in use as a place of worship in the city of Newcastle. It is first mentioned in the Chartulary of Tynemouth Monastery in the year 1218. The exact year of its construction is lost to time, but experts agree that it dates from the mid-twelfth century, as the erection of the church has been credited to David, King of the Scots, who died in 1153. The exceptional Norman arch, which separates the nave from the chancel beyond, dates from the original building, and some of the stones used to build the tower are reclaimed Roman material. This church received considerable damage during the siege of Newcastle in 1644, due to its close proximity to the city walls, and a gun emplacement was positioned within the churchyard to defend the wall. It is recorded that a 'breach was made in the wall near to the church capable of admitting ten men abreast'. The church underwent many periods of repair and remodelling during the eighteenth century,

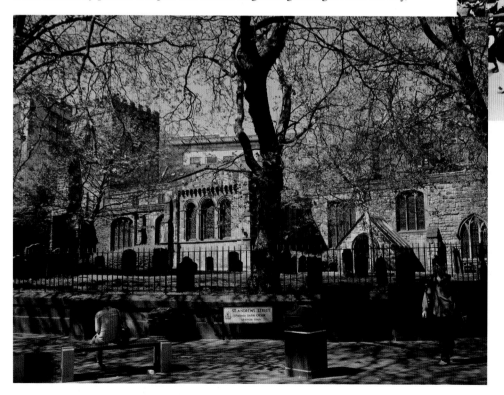

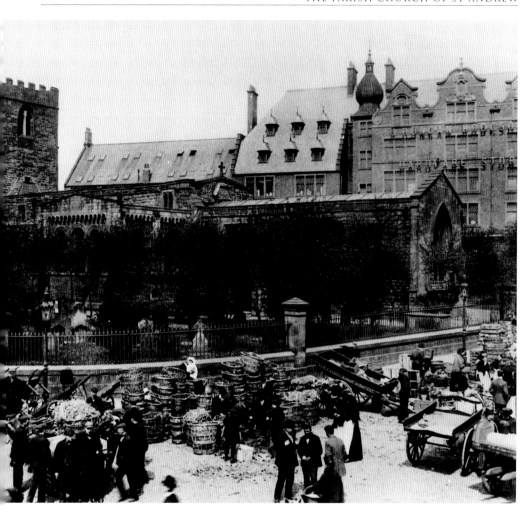

including the gallery at the west end of the church being demolished in 1782, and the present one built for the organ. In 1844, further alterations were made by famous Newcastle architect John Dobson. The choir stalls were made by Ralph Hedley of Newcastle in 1907, built to replace the outdated box stalls. He also made the Bishop's chair and oak pulpit.

TWO OF THE oldest gravestones in the city are to be found within the chancel. To the left of the altar is the first, which bears three horseshoes and the inscription *Orate pro anima thome lyghton*, a Latin phrase which translates as 'Pray for the soul of Thomas Leighton', who was the Sheriff of Newcastle in the 1400s. Less is known of the second grave, which is decorated by the sign of a cross – the only word which can still be made out on the time-worn stone is 'sinister'. The Corporation of Newcastle took over the upkeep of the churchyard during the 1950s, and today it is dissociated from other churches in the city and exists in its own right as a parish church. It is nestled away in one of the busiest corners of the city, and many thousands of people pass by its leafy churchyard every day.

ST ANN'S CHURCH

THE GRADE I LISTED church of St Ann's on City Road (pictured on the right in 1912) was consecrated by Bishop Trevor on 2 September 1768. The City Corporation had paid to have a new church built, with work commencing in 1767. It was largely constructed with stone reclaimed from the ruined town walls, to the design of leading Newcastle architect William Newton, whose legacy of work includes the Assembly Rooms, and Kielder Castle, a grand hunting lodge built for the Duke of Northumberland in 1775. The site upon which the church was built had been used as a place of worship for many years, dating back to 1344, when a small chapel was constructed for St Ann and her daughter, St Mary the Virgin. Many victims of the last great cholera epidemic were laid to rest in the churchyard at St Ann's. The English Renaissance-style church stands as beautiful today as it did when it was built almost 250 years ago. The only amendment to the structure of the building came in the nineteenth century, when the nave windows were narrowed. The interior has been improved and modernised as the years have passed by.

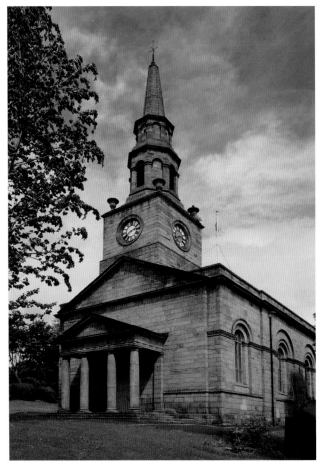

IN 1999, THE Friends of St Ann's was established to work alongside the Parochial Church Council to 'maintain and enhance the Grade I listed church and its churchyard.' The summer of 2007 saw restoration of the original stonework and railings completed. Repairs were also made to the war memorial. This work was made possible with the help of a Heritage Lottery grant and additional funds from local charitable trusts. Although primarily a place of worship, St Ann's Church has also hosted concerts by a number of local amateur folk and jazz groups; one such group have named themselves the St Ann's Chamber Players, and perform an annual charity concert at the church.

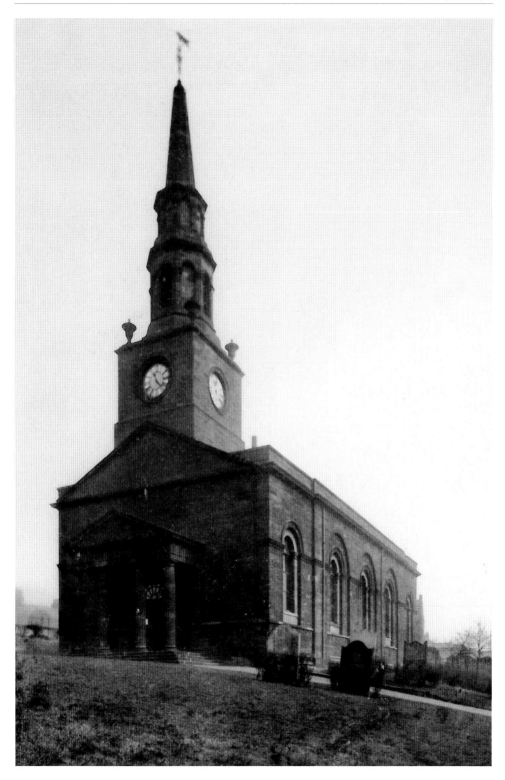

ST JAMES' PARK

ST JAMES' PARK has been the home of Newcastle United Football Club since 1892. It is the third largest club football stadium in England, with a capacity for 52,387 people – only Old Trafford and the Emirates Stadium can accommodate more fans. While the stadium is now synonymous with the Black and Whites, Newcastle United actually played in red and white at St James' Park until 1904. This photograph (right), taken in 1965, came at a period when the history of St James' Park was uncertain. Plans were being drawn up to build a new stadium in Gosforth, or for the club to move to Wearside and share a new ground with local rivals Sunderland AFC, a move that would not have gone down at all well with the fans of either club. Thankfully, both of these plans were withdrawn in 1971, when a decision was made to redevelop St James' Park.

In 1995, the stadium, with a seating capacity for 36,610 people, was full for every home game due to the success of the team, led by manager Kevin Keegan. Plans were submitted to relocate to Leazes Park, in a brand new £65 million, 55,000-seat stadium. However, the people of Newcastle, horrified by the thought of losing Leazes Park, submitted a petition with 36,000 signatures on it. To satisfy demand, the club chose to expand the current stadium further.

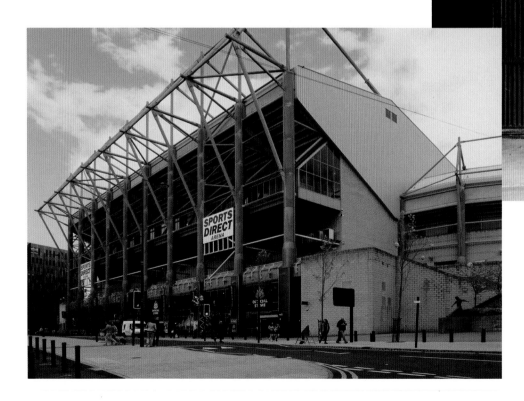

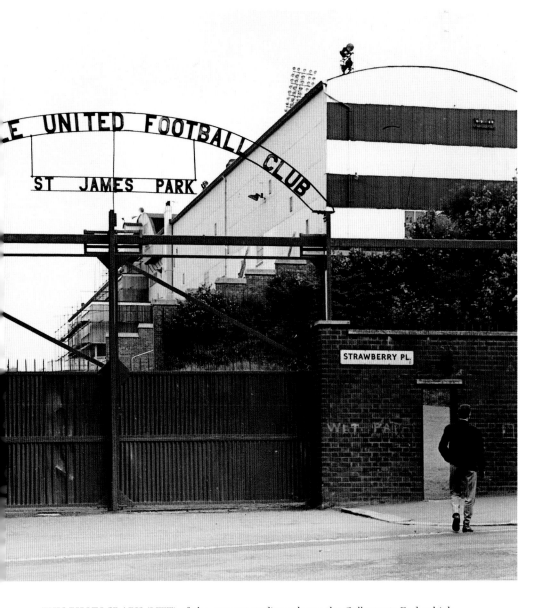

THIS PHOTOGRAPH (LEFT) of the current stadium shows the Gallowgate End, which houses Shearer's Bar, a popular bar in Newcastle and named after former number 9 and terrace hero, Alan Shearer. Besides club football, St James' Park has also been used for international football, most recently during the 2012 Olympics, and it will also be used as a rugby venue for the 2015 Rugby World Cup. In addition to professional sports, the stadium has hosted charity football events and rock concerts. It is also a popular wedding venue, and regularly hosts exhibitions and business meetings. Controversially, a few years ago, St James' Park was renamed the 'Sports Direct Arena' for sponsorhip money. However, in October 2012 the stadium was once again named St James' Park, due to sponsorship agreements and much to the delight of the Newcastle United football fans.

SWING BRIDGE

THE FIRST BRIDGE across the Tyne was built by the Romans. It was a wooden bridge built on stone piers, and was completed in around AD 120. In 1270, the bridge was entirely rebuilt in stone, but was swept away when the Tyne flooded in November 1771. A replacement was built in 1781, but it was so low to the water that problems arose, as it prevented coal being transported efficiently from down river and larger vessels from moving upstream to Armstrong's factory at Elswick. In 1864, the Armstrong factory, which had been manufacturing hydraulic equipment and cranes, began a potentially lucrative enterprise fitting lightweight guns of their own design

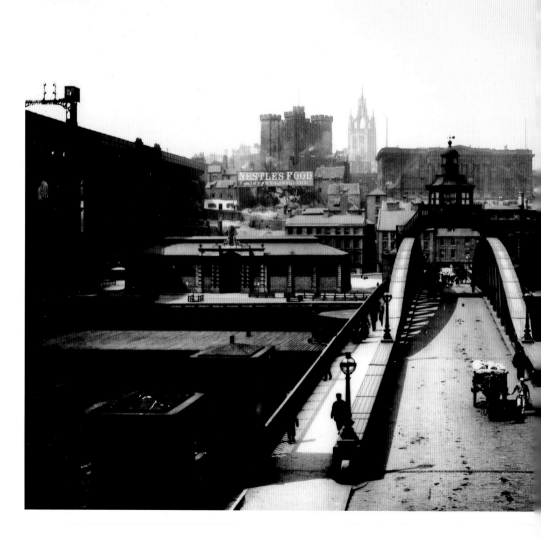

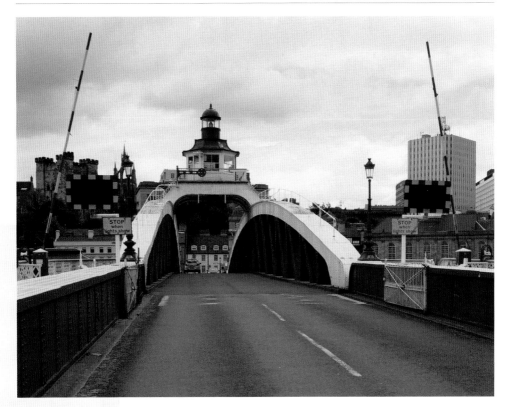

to warships. William Armstrong offered to pay for the building of a new bridge, should the current bridge be removed. A temporary bridge was constructed in 1866, and, in 1868, the old bridge was demolished. Armstrong designed and paid for a hydraulic swing bridge, powered by steam pumps, to be built. This design would enable the bridge to rotate 360° to allow large ships to pass. Pictured on the left in 1889 from the Gateshead side of the river, this new bridge weighed over 1,200 tonnes, and was opened to road traffic on 15 June 1876 and to river traffic on 17 July 1876.

IN 1959, ARMSTRONG'S steam pumps were replaced by electric pumps. A solution to a long-standing problem with the bridge was discovered a few years later in the early 1960s; a heatwave could prevent the bridge being opened, as the heat would cause the metal to expand and 'weld' to its mountings, and the fire brigade would be called in to douse it with water. The solution came in the form of a light paint which reflected the heat. The bridge still provides a vital road crossing and is permanently manned. The Swing Bridge often takes part in Heritage Open Days, offering members of the public a rare glimpse inside the bridge's control room.

THE CATHEDRAL CHURCH OF ST MARY

IN 1838, THE Catholic people of Newcastle were poor but their faith was unwavering, and a meeting of the local Catholic populous passed a resolution – 'it behoves the Catholic body to endeavour to erect a large and handsome church, that may be at the same time as being an honour to their religion, an ornament to the town, and capable to afford sitting for about twelve hundred persons'. A committee was formed and £6,500 was raised (the equivalent of almost £1m today), with Augustus Welby Pugin, a champion of the Gothic Revival style of architecture, being commissioned to design the building (pictured here around 1920). The construction began in 1842 and the church was opened on 21 August 1844. The completed building was very much as Pugin designed it, except his tower and steeple were not built due to the tight budget. In 1850,

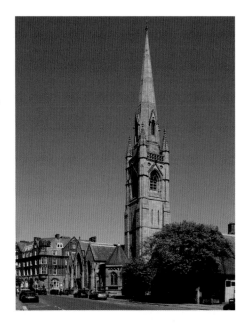

the newly appointed first bishop of Hexham and Newcastle selected St Mary's as his seat and it gained the status of Cathedral Church. The tower and steeple of Pugin's design were added later, following a bequest from Elizabeth Dunn, who died in 1870. During the Second World War, the stained-glass windows suffered when the city was bombed, this resulted in the windows on the south wall being replaced by plain glass, as the money wasn't there to replace the stained-glass windows.

TODAY, THE CATHEDRAL Church of St Mary stands as a Grade I listed building, and has been continuously improved and expanded as the years have passed, with each of the thirteen Bishops having made their mark on the magnificent cathedral – the fifth tallest building in twenty-first-century Newcastle. Extensive repairs took place on the roof in the 1980s, which had been suffering from a severe case of dry rot. During this period, all of the internal stonework was carefully cleaned and restored. In June 2003, Bishop Ambrose opened the new Diocesan Books and Media Centre, and another new addition to the Cathedral, the Cloister Café, was opened on the same day. In 2004, one of the stained-glass windows destroyed during the bombings was replaced with the first stained-glass window to be installed in the cathedral in over 100 years. The window was dedicated to the life of Private Adam Wakenshaw VC, the only member of the forces from Tyneside to be awarded the Victoria Cross in the Second World War. He was awarded this posthumously, having sacrificed his own life to save his comrades during a battle at Mersa Matruh on 27 June 1942.

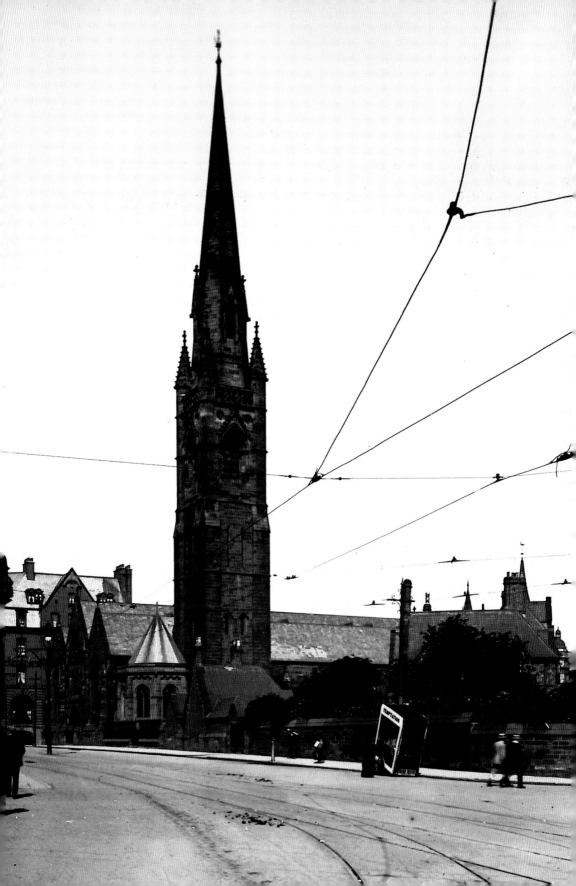

THE CATHEDRAL CHURCH OF ST NICHOLAS

THE CATHEDRAL CHURCH of St Nicholas began life as a parish church and was named after the patron saint of sailors and boats. The church was built in 1091, shortly after completion of the new castle in 1080 by William the Conqueror's eldest son, Robert. The wooden church was rebuilt in stone in the twelfth century, and suffered damage from fire in 1216, being restored in 1359. The church was improved and expanded over the years that followed. The unusual spire, for which the cathedral is noted, was added in 1448.

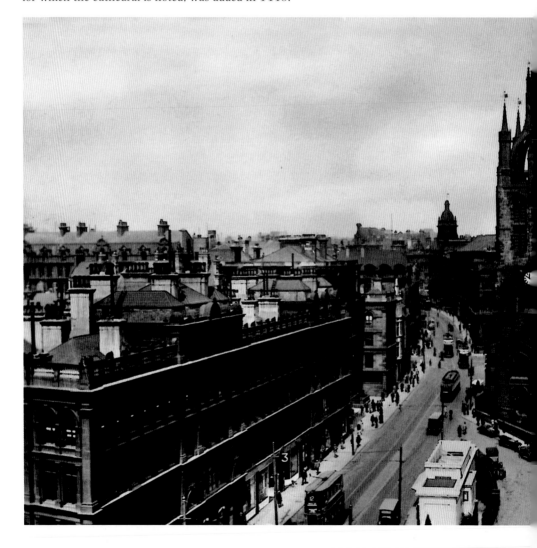

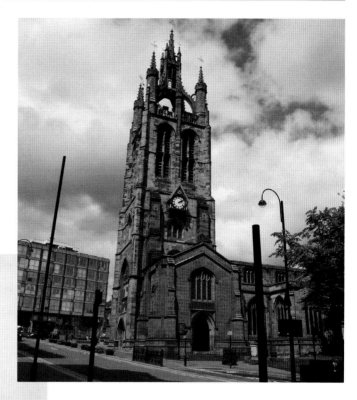

The cathedral is 196ft 6in (59.89m) from the base to the top of the steeple. During a siege by the Scottish in 1644, which lasted nine weeks, the church was surrounded and the Scottish General threatened to destroy it unless the keys to the walled city were handed over to them. The Mayor of Newcastle had over 100 Scottish prisoners brought to the church and placed in the tower. The Scots relented, realising that opening cannon fire on the church would result in the death of their own.

In 1882, the Diocese of Newcastle was created by Queen Victoria, and the church became the Cathedral Church of St Nicholas; the most northerly cathedral in England. In the early twentieth century, local artist and craftsman Ralph Hedley designed the nave furnishings. The tower contains a complete ring of twelve bells – including the tenor bell which weighs almost two tons – plus three fifteenth-century bells.

TODAY, THE GLORIOUS cathedral continues to serve the community as a place of worship with daily services and offering home-cooked meals at the Lantern Café.

NEWCASTLE CENTRAL STATION

NEWCASTLE ARCHITECT JOHN Dobson designed the Newcastle-upon-Tyne Central station for the York, Newcastle and Berwick Railway, and the Newcastle and Carlisle Railway. The station was constructed in collaboration with Robert Stephenson, who designed the High Level Bridge,

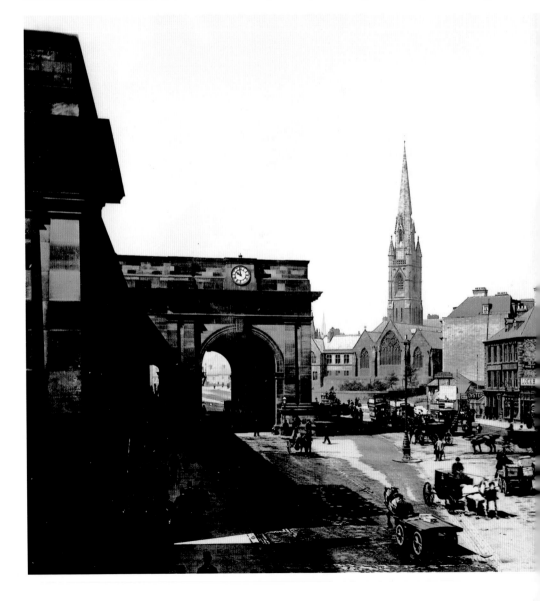

which opened in 1849 to the south-east of the station and allowed trains to cross the River Tyne. Work on the station began in 1845 and took five years to complete. The opening ceremony took place on 29 August 1850, and the station was officially opened by Queen Victoria and Prince Albert. The momentous day was one that would live long in the memory of all who attended; however, it would see the city fall out of favour with Her Majesty. After a celebratory banquet, the bill was presented to Queen Victoria, and it is said that her offence at the incident led to her drawing the blinds on her carriage whenever it passed through Newcastle. Having originally been named Newcastle-on-Tyne Central, the name of the station was simplified to Newcastle at some point between 1948 and 1953. The completed station had a neoclassical frontage. Dobson had intended it to have a colonnaded front and Italianate tower, however, this vision was never realised. The portico that remains to this day was designed by Thomas Prosser and added to the station entrance in 1863.

THE INTERIOR OF this Grade I listed building has changed dramatically over the years and now has twelve platforms, with a combined length of almost 2 miles. The station is at the centre of the city's transport system, and served 7.5 million travellers in 2011.

THE HOPPINGS

THE NORTH OF England Temperance Fair first took place on the Town Moor, a large area of common land in the city, in 1882. It attracted around 200,000 people during the two-day event. It was scheduled to coincide with Race Week at Newcastle Racecourse, during which the Northumberland Plate was awarded. The rent paid by the showmen was £10. The fair quickly became known as the Hoppings, a name by which it has been known ever since. Several origins have been suggested for the name, with the most likely relating to dancing. In the early days a bonfire was lit as people drank and feasted, before they would dance and hop round the fire to the music of local pipers.

During the First World War, the fair took place in Jesmond, as troops were trained on the Town Moor, and a section of it was also used as an airstrip. It returned to the more spacious Town Moor in 1919. There was no Festival on the Moor between 1920 and 1923, with a small fair taking place in Jesmond instead, but it returned in June 1924, where it continued annually until 1940, when the outbreak of the Second World War saw many of the showmen being called up to the armed forces. The Hoppings returned to the Town Moor in 1947 and it has been held uninterrupted ever since.

This image (above) was taken in 1957; a big attraction at the Hoppings in this year was an appearance from Edith Barlow, the shortest woman in the world, standing at just 22 inches and weighing 17lb. Sadly, she fell ill while on the Moor and died of pneumonia in hospital.

THE HOPPINGS CONTINUED to grow and is today Europe's largest travelling funfair. To the people of the city, the Hoppings is as Geordie as Ant and Dec, Newcastle Brown Ale, or pease pudding. It runs annually on the last week of June, on a 30-acre section of the Town Moor, to which tens of thousands of people turn up daily, greeted by the unmistakable smells of frying onions and doughnuts, and visit over 300 attractions and over 100 exciting rides. In 2012, the Hoppings was disrupted by the wettest weather the fair had ever had to endure. The opening was postponed by two days due to extremely heavy downpours, which caused the Town Moor to become waterlogged. This was only the second time in its history that the opening had been delayed. A few days later, however, the Hoppings couldn't run due to the worst storm in living memory, in which two months of rain fell in just two hours and 1,500 individual lightning strikes illuminated the skies above the city.

THE OLD GEORGE INN

THE OLD GEORGE Inn is described by the current owners as a 'Newcastle treasure', and few who have drank in the city's oldest pub would disagree. Situated in the Cloth Market, in the heart of the Bigg Market – famed as the bustling hub of Newcastle's nightlife – the Old George is a popular traditional public house dating back to the seventeenth century. It began life as a coaching inn and retains the original wooden beams and low ceiling. The most famous patron of the Old George's long history is King Charles I, who drank at the pub on a number of occasions in 1646.

He was being held captive by the Scots on Pilgrim Street, and they allowed him to go and play a round of golf on the Shieldfield, before stopping off afterwards for a drink. The chair in which he sat remains to this day in the 'King Charles Room'. This image (opposite) was taken in 1960 and shows the pub yard and the entrance to the King Charles Room through the doorway beneath the 'Bass' sign, which also bears the name 'Ye Olde George'. In 1928, the pub faced the very real possibility of being closed down, however, the owner was granted a reprieve, providing they improved the ventilation, painted and cleaned throughout, and offered modern lavatories.

TODAY, THE OLD George remains a charming traditional pub well worth visiting for a quiet drink of 'Newkie Broon' (or Newcastle Brown Ale to non-Geordies), or a bite to eat in the city centre. It can be very lively on Friday and Saturday nights, with DJs a regular feature to cater for the vibrant Bigg Market nightlife.

THE ROYAL STATION HOTEL

THE ROYAL STATION Hotel is an imposing Victorian building right in the heart of Newcastle city centre. It stands directly next to Newcastle Central Station. It was opened in 1858 by Queen Victoria and Prince Albert as a four-storey hotel, complete with a clock tower that also contained a water tank. In 1890, a six-storey hotel extension was built, and the original hotel had two further floors added. The city had expanded over the decades, with bigger and better buildings, and, because the clock tower was now concealed by taller buildings, the clocks were transferred to

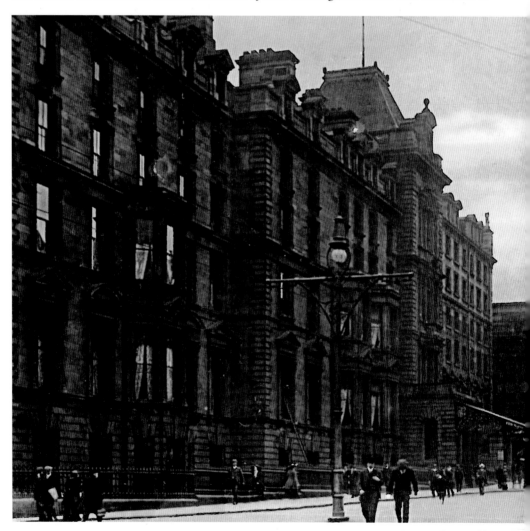

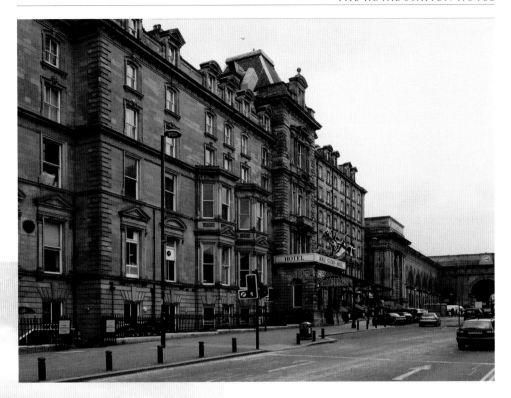

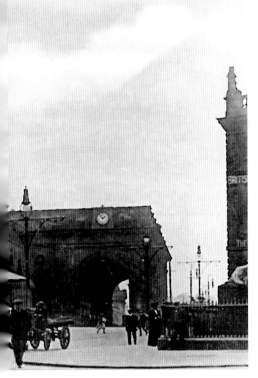

the station portico, where they remain today. This photograph (left) was taken in around 1910 and shows smartly dressed Edwardian men and women passing the elegant Victorian hotel frontage.

OVER 100 YEARS later, the exterior of the popular three-star hotel, which is part of the Cairn Group, hasn't changed much – the Victorian architecture is as magnificent as ever. The interior has been modernised throughout and now features all of the amenities that you would expect from a top hotel. There are 144 en-suite bedrooms, all of which have direct dial telephone, a writing desk, a television, and high-speed Internet access. The hotel also has its own leisure club, with an indoor swimming pool, steam room, jacuzzi, and fitness area. The on-site restaurant is called the Empire Restaurant, and there is also the popular Destination Bar. For visitors to the city, whether on business or pleasure, the Royal Station Hotel is a wonderful base from which to explore Newcastle.

THEATRE ROYAL

THE ORIGINAL THEATRE Royal was built by David
Stephenson and opened in Newcastle on 21 January 1788,
but when Richard Grainger began his redevelopment of the
city centre, the building obstructed his plans for Grey Street.
The original theatre's final performance was on 25 June 1836,
after which it was demolished. Grainger had committed to
building a replacement and enlisted father and son architects
John and Benjamin Green to design it. The present Theatre
Royal, pictured on the right in 1927, opened on 20 February
1837 with a performance of Shakespeare's *The Merchant of
Venice*. The portico was designed in keeping with the rest of
Grey Street, with six huge Corinthian columns rising up from
plinths that support a classical triangular pediment bearing
the royal coat of arms. The exterior was magnificent, and
the interior was every bit as grand. Following a performance
of *Macbeth*, the building was gutted by fire in 1899. The
interior was redesigned by Frank Matcham and reopened on
New Year's Eve 1901. It was remodelled again in 1987 by
the Renton Howard Wood Levin Partnership, who retained
Matcham's balconies and boxes.

IN MARCH 2011, the Grade I listed Theatre Royal closed for six months as it underwent a major restoration costing £4.75 million. This saw the interior of the theatre restored to Frank Matcham's 1901 design, as well as considerable upgrades throughout. It reopened on 12 September 2011 with Alan Bennet's *The Madness of George III*. In February 2012, the theatre celebrated its 175th anniversary with a birthday gala. Every year, over 300,000 people come to take in a show, with over 70,000 of them coming to see the Christmas pantomime. It is the regional home of the Royal Shakespeare Company, the National Theatre, Rambert Dance Company, and Opera North.

TYNE BRIDGE

THE TYNE BRIDGE is arguably Newcastle's most iconic landmark; a through arch bridge spanning 531ft over the River Tyne, linking Newcastle and Gateshead. The suggestion of placing a bridge at this point of the Tyne was first raised in 1864, brought about because of the toll cost on the High Level Bridge. However, it wasn't until 1924 that Newcastle and Gateshead authorities approved the construction of a Tyne bridge. The estimated cost was £1 million, including land acquisitions. Work started in August 1925, with Middlesbrough bridge builders Dorman Long – who also worked on Sydney Harbour Bridge – acting as the building contractors. The work was very dangerous and one of the workers, Charles Tosh, lost his life during construction. The bridge was completed on 25 February 1928, with the final cost at completion being £1.2 million. It was

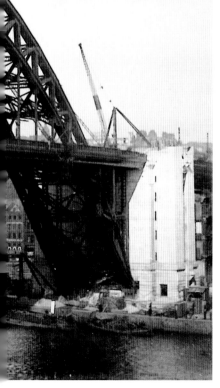

opened on 10 October by King George V and Queen Mary, who were the first to use the roadway. The Tyne Bridge's great towers were designed by Newcastle architect Robert Burns Dick, and are built of Cornish granite. On 10 October 1978, to celebrate the fiftieth anniversary of the bridge, 1,000 balloons were released into the sky above the Tyne Bridge. To mark the occasion, the opening ceremony was re-created, with vintage vehicles and a procession of people in period dress.

THE BRIDGE IS used by around 60,000 vehicles each day, and, due to deterioration of the road surface, major renovations were carried out in 1999. The following year, the bridge was repainted in the same colour green that it had been when it was originally constructed. The Tyne Bridge will forever be associated with the annual Great North Run, with over 50,000 runners crossing it at the start of the race as the Red Arrows fly overhead.

During the summer of 2012 the Olympic Rings were erected on the bridge, symbolising the Olympics being held in London. These were illuminated each night.

If you enjoyed this book, you may also be interested in …

Ghostly Tyne & Wear
ROB KIRKUP

Ghostly Tyne & Wear investigates thirty of the most haunted locations in Tyne & Wear today. This selection includes a phantom highwayman at Blacksmith's Table Restaurant in Washington, a mischievous poltergeist at the the Central Arcade in Newcastle-upon-Tyne, as well as sightings of phantom soldiers at Arbeia Roman Fort in South Shields. Illustrated with over sixty photographs, this book is sure to appeal all those interested in finding out more about the area's haunted heritage

978 0 7509 5109 8

The Avenue: A Newcastle Backstreet Boyhood
SAMUEL W. HERBERT

Samuel Herbert had to grow up fast when his family moved to a cockroach-infested tenement in Newcastle while his Dad was away fighting on the front line. Along with the shared 'netties' and the terrible living conditions, Samuel learned how to deal with bullies and gangs until he grew just as tough. Along with the tragedy, however, came lots of laughs, and Samuel's unique account demonstrates the humour, courage and indomitable spirit of the local population.

978 0 7524 6886 0

The Little Book of Newcastle
JOHN SADLER AND ROSE SERDIVILLE

The Little Book of Newcastle is a funny, fast-paced, fact-packed compendium of the sort of frivolous, fantastic os simply strange information which no one will want to be without. Here we find out about the most unusual crimes and punishments, eccentric inhabitants, famous sons and daughters and literally hundred of wacky facts.

978 0 7524 6044 4

The Great Siege of Newcastle, 1644
ROSIE SERDIVILLE AND JOHN SADLER

In the autumn of 1644 was fought one of the most sustained and desperate sieges of th First Civil War in Newcastle-upon-Tyne. Newcastle had held sway in the north-east since the outbreak of the war in 1642, and this book tells the story of the people who fought there, what motivated them and who led them there. Drawing on contemporary source material, some of which is previously unseen, this account of what happened on the day a minute-by-minute chronicle of Newcastle's bloodiest battle.

978 0 7524 5989 9

Visit our website and discover thousands of other History Press books.

www.thehistorypress.co.uk